The Quick and the Dead

Artists and Anatomy

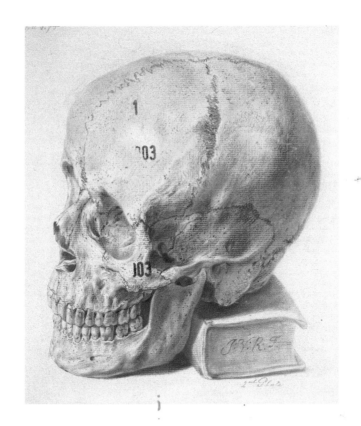

National Touring Exhibitions

sbc

A National Touring Exhibition organised by the Hayward Gallery, London, for the Arts Council of England

Exhibition tour:
Royal College of Art, London
28 October – 24 November 1997

Mead Gallery, Warwick Arts Centre, Coventry
10 January – 14 March 1998

Leeds City Art Gallery, Leeds
28 March – 24 May 1998

Exhibition selected by Deanna Petherbridge
Exhibition organised by Andrew Patrizio and Ann Elliott, assisted by Julia Coates
Installation design by Penoyre and Prasad
Design consultant Calum Storrie
Education material by Helen Luckett

Catalogue designed by Herman Lelie
Typeset by Stefania Bonelli
Printed by P.J. Reproductions Limited

Front cover: J.-F. Gautier d'Agoty, *Muscles of head, eye and larynx*, 1746, Wellcome Institute for the History of Medicine, London (cat. 73) (detail)
Back cover: W. Cheselden, Plate from *Osteographia*, 1733, Stephen Cox (cat. 50) (detail)
Frontispiece: Jan van Riemsdyck, *Skull on a book*, c. 1755, The Royal College of Surgeons of England (cat. 125) (detail)

National Touring Exhibitions, Hayward Gallery and Arts Council Collection publications are distributed by Cornerhouse
Publications, 70 Oxford Street, Manchester M1 5NH (tel. 0161 237 9662; fax. 0161 237 9664).

Note
The various spellings of artists' names and works as provided by the lenders have been retained throughout.

Preface

The title for this exhibition, *The Quick and the Dead*, is taken from the apostolic creed. It alludes both to the exhibition's basis in the study of skeletons, écorchés and dissected bodies, and to those alive, imaginatively, to the incredible mysteries of the body. The drawings, prints, books, photographs and objects included in the exhibition span five centuries and mark numerous cultural shifts, yet the imagery is as relevant and powerful today as it was when it was created, and artists continue to engage with the subject.

The idea for this exhibition originated with its selector, Deanna Petherbridge, Professor of Drawing at the Royal College of Art in London, whilst visiting Glasgow University Library, where she saw Jan van Riemsdyck's beautiful red chalk drawings for William Hunter's classic textbook *Anatomy of the human gravid uterus*. These drawings are among the many extraordinary works chosen by Deanna Petherbridge from the worlds of art and medicine for this exhibition, and we are enormously grateful to her for the dedication, energy and eye she has brought to the demanding task of selection. The Hayward Gallery collaborated with Deanna Petherbridge in 1991 when she selected another of our National Touring Exhibitions, *The Primacy of Drawing*. Once again, her profound knowledge of the art of drawing, and her familiarity with some of the finest collections of drawing in Europe, has been instrumental in the creation of an exhibition of great richness and complexity. Research for this project has led us all into unfamiliar territories, and particularly into medical collections whose objects and artworks are only now beginning to be appreciated by the non-clinical world.

We gratefully acknowledge the efforts made by colleagues in the collections of historical works, who have generously given Deanna Petherbridge access to their holdings and facilitated loans. We are greatly indebted to the directors, curators, administrative and technical staff of these institutions, as well as to the individuals who have made their own collections available, all of whom, like us, believe in the value of this exhibition and the importance of presenting it to the widest possible audience. Special thanks are due to

Ludmilla Jordanova, Professor in the School of World Art Studies and Museology at the University of East Anglia and an international authority on the relations between visual culture, history and medicine, for her thought-provoking essay. We are similarly grateful to the many people who have been involved in preparations for the exhibition and who are listed opposite. We also remain particularly indebted to our lenders, those listed in this catalogue and those who wish to remain anonymous, without whose extraordinary support this show would not have been possible. I would like to extend my thanks as well to Andrew Patrizio, who initially organised the exhibition, to Ann Elliott, who saw it through its later stages of development, and to Julia Coates, for her attention to detail and commitment to the project throughout.

The Quick and the Dead highlights the collaborative instinct shared by those who practise the visual arts and the medical sciences. The small but important selection of works in the exhibition by contemporary artists who use anatomical imagery is testament to the fact that, whilst methods of scientific representation are changing radically and no longer employ the skills of academic draughtsmanship, the disturbing power and graphic intensity of these historic works clearly still fascinate and inspire.

Susan Ferleger Brades
Director, Hayward Gallery

Acknowledgements

Claire Allman; Ken Arnold; A.Th. Bouwman; P. Buisseret; Anthea Callen; Andrea Carlino; Ruth Charity; Antony Griffiths; Cindy Hubert; Nasser D. Khalili; Monique Kornell; Francis McKee; Theresa-Mary Morton; Janice Reading; Jane Roberts; Russell Roberts; Sarah Rogers; Sarah Shalgosky; Nigel Walsh; David Weston; and all the staff of the Hayward Gallery and SBC who contributed towards the realisation of the exhibition.

Selector's Acknowledgements

I could not have researched this exhibition and catalogue without the help of many people who have warmly welcomed me into their collections and libraries or been generous with information and support. In particular, I owe a huge debt to Monique Kornell, who has been exceptionally generous with her time and scholarship and Ludmilla Jordanova from whom I have learned so much. My warm thanks to Martin Kemp who not only supplied me with references early on but invited me to participate in the exhibition *Materia Medica* at the Wellcome Institute for the History of Medicine and so to make the acquaintance of Ken Arnold who has been wonderfully helpful, as have William Schupbach and John Symons of the Wellcome Institute. Jane Roberts and Martin Clayton of The Royal Collections, Windsor allowed me to spend some of the most rewarding hours of my life in communing with Leonardo da Vinci's anatomical drawings at Windsor Library. Antony Griffiths of the Prints and Drawings Department of the British Museum gave me the benefit of his extraordinary knowledge and every single member of that department has been helpful, including Sheila O'Connell, Frances Carey, Martin Royalton-Kisch, Giulia Bartrum, Jenny Ramkalowan, Andrew Clary, Angela Roche and Janice Reading, Mary Bagulay and Yvonne Ashcroft. Tim Boon of the Science Museum has given me many enjoyable hours of his time and David Scrase of the Fitzwilliam was extremely helpful. David Weston of Special Collections, University of Glasgow Library and Nicholas Savage of the Royal Academy Library have been patient, good humoured and inventive with suggestions, as was Tina Craig of the Library of the Royal College of Surgeons. Susan Lambert of the Victoria & Albert Museum was very supportive. Michael Rogers took time to show me the Khalili Collection and Emilie Savage-Smith was exceptionally generous with information. Pelé Cox undertook research for me with interest and enthusiasm. Julia Coates has laboured long and hard on behalf of this exhibition, and I am very grateful to her, to Andrew Patrizio, Helen Luckett, Ann Elliott, Greg Hilty, Linda Schofield and Roger Malbert. My sister Pam Sacks has been patient and wise on a long-distance telephone line and Peter Townsend has given me the benefit of his experience. It has been a pleasure to work with designer Herman Lelie, and with architects Sunand Prasad, Greg Penoyre and Andrew Siddall. My sincerest thanks to Claire Allman, Ingrid Bleichroeder, Anthea Callen, Andrea Carlino, Stephen and Judy Cox, Caroline Cuthbert, J.J. Daws, Katy Deepwell, Meg Duff, Anne Engels, Christopher Frayling, John Hayes, Frances Jowell, Nicola Kalinsky, Bridget Landon, David Lomas, Jane McAusland, Martin Postle, Al Rees, Tessa Sidey, Sarah Simblet, Murray Simpson and Robert Skelton.

Deanna Petherbridge

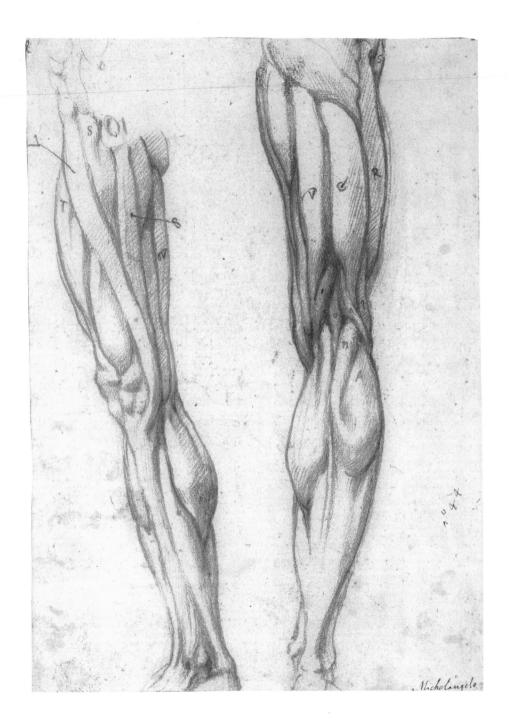

112
attrib. to Michelangelo Buonarroti
Écorchés of a Male Leg: on the left, an extended right leg and the same leg seen from the back, c. 1520

Art and Anatomy: The Meeting of Text and Image

Deanna Petherbridge

Introduction

The body has been central to Western Art for most of its history, and to represent bodies in all their expressivity artists have needed to study anatomy: dissecting the dead in order to depict the living.

The Quick and the Dead: Artists and Anatomy reveals a series of hidden histories. Hidden, in the sense that the interior of the body is concealed from sight, and could only be explored until recently by invasive or even violent acts against the living or dead body. And as these acts have at all times and in all cultures constituted a taboo, anatomy and surgery have been fenced around with rituals and circumscriptions, which have found a metaphorical place within the imagery. Hidden too, in the sense that, for artists, drawing human and animal anatomy has either been part of academic study or a preparation for more finished works, and therefore has constituted a private studio practice. And hidden because many of the drawings and objects made by artists and anatomists have been regarded in the 20th century as too disturbing for a non-medical audience, and have been stored out of sight in museum collections and libraries. Nowadays, when most of the British public watches surgical operations on television over a meal or relaxes in the sitting room to bloody acts of violence, this material has assumed another status. If some of it is still disturbing – such as the amazing coloured mezzotints of Jacques Gautier d'Agoty (cats. 72 and 73) – nevertheless we can also appreciate the artistry and imagination which has informed the imagery.

This is not a chronological survey of art and anatomy, although it contains works from the 15th century to the end of the 20th century. Rather, the intention is to thematise certain relationships between anatomy, cultural constructions of the body and images made by artists within this very complex field. Some themes more-or-less coincide with particular

periods and geo-political concentrations because medicalised and artistic bodies are historically specific (*Crary et al*, 1989, pp. 471–575). In other respects, it is astonishing how artists from different cultures and different times, including the present, have unwittingly explored similar visual solutions when addressing the horror, the pathos, the vulnerability or the factuality of the anatomised body.

Artists and the Study of Anatomy

In the 15th and 16th centuries, 'artist-anatomists' made a huge contribution to the newly emerging 'sciences' of body knowledge through their own dissections and drawings, foremost amongst them Michelangelo and Leonardo da Vinci.[1] Leonardo's anatomical notebooks (many of them now in the collection of Her Majesty the Queen at the Royal Library, Windsor) were intended for publication, and a number of other artists, including Alessandro Allori, prepared (and occasionally published) anatomical textbooks (*Barzman*, 1989; *Kornell*, 1993).[2] The study of anatomy was deemed so important that it was included in the programmes of instruction in the earliest Italian academies, although scholars dispute whether dissections took place more on paper than in practice. In an early 17th century Italian engraving by a little known artist associated with the Rome academy, Pietro Francesco Alberti, the ideal pedagogic programme for training artists is conceptualised in a collage of separate activities (cat. 17). In addition to the study of geometry (using figures borrowed from Raphael), artists are seen drawing from a full skeleton and from a model of a leg, while a group of young students are eagerly clustered around a dissected corpse on a table, which the dissector's assistant is disembowelling. The study of anatomy was obligatory in the French Académie Royal de Peinture et de Sculpture, founded by painters in 1648, as well as in the academies which were established in other European countries (*Boschloo*, 1989). Sir Joshua Reynolds appointed his friend William Hunter, the renowned obstetrician and connoisseur, to the post of official anatomist when he founded the British Royal Academy of Arts in 1768.[3] Generally, however, artists have worked from three-dimensional écorchés (models or drawings of flayed human figures) or anatomy picture books. 'Useful' anatomy for artists has mainly been the study of the skeleton and of myology

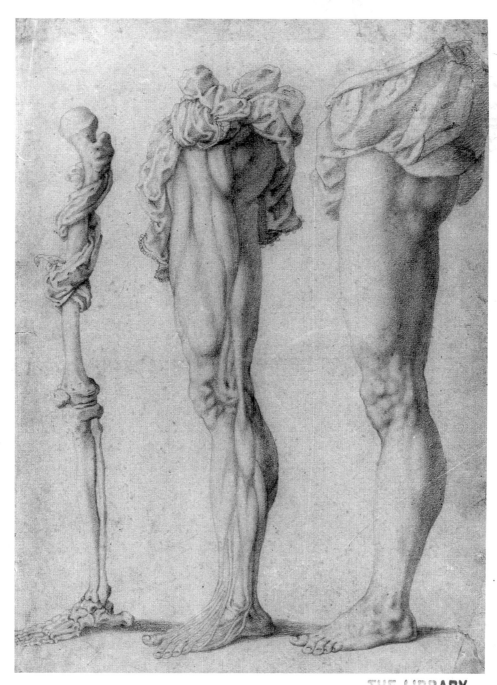

19
Alessandro di Cristofano di Lorenzo Allori
A man's left leg, progressively anatomised, mid-1560s

(particularly superficial musculature), especially in so far as it affects bodily form, gender, movement and expression. Drawings based on close scrutiny for study purposes therefore span the centuries (cats. 78 and 113).

Anatomical studies disappeared from most British art schools in the post-Second World War period as artists moved away from bodily representation, and from perceptual to abstract and conceptual art. Recently, however, the artistic preoccupation with identity has meant a return to the subject in a very different way. In a subject/object shift, the artist's own body has taken the place of the model 'out there', and has become the art work. For example, American artist Robert Gober deals with his own sexuality in an untitled work of 1990 which seamlessly unites male and female elements in a wax torso, sealed top and bottom like a paper bag: the body as a container of meanings (cat. 84). Artists no longer refer to 'figure' drawing but to the 'body', which is conceived as a cultural construct, inscribed with social, sexual and gendered meanings. Photography and new media have tended to take over from drawing as the means of re-presenting the body, but in recent years artists have become fascinated with the anatomy theatre and anatomical museum as spectacle; Damien Hirst is one such example.

Drawing and Dissection

The meeting of artists and anatomists around the dissecting table has focused on the act of drawing as well as explication of the body. On the whole, artists have drawn from dissected cadavers in association with anatomists: Michelangelo, for example, is recorded as having worked at one time with Realdo Columbo.[4] Leonardo da Vinci, who had contact with the anatomist Marcantonio della Torre, claimed to have undertaken up to thirty dissections of human and animal subjects on his own, and George Stubbs, who cut up his first animal at the age of eight, was an ardent anatomist (*Doherty*, 1974). Leonardo noted in his unpublished anatomical notes: 'And though you have a love for such things you will perhaps be impeded by your stomach... [or] the fear of living through the night hours in the company of quartered and flayed corpses fearful to behold. And if this does

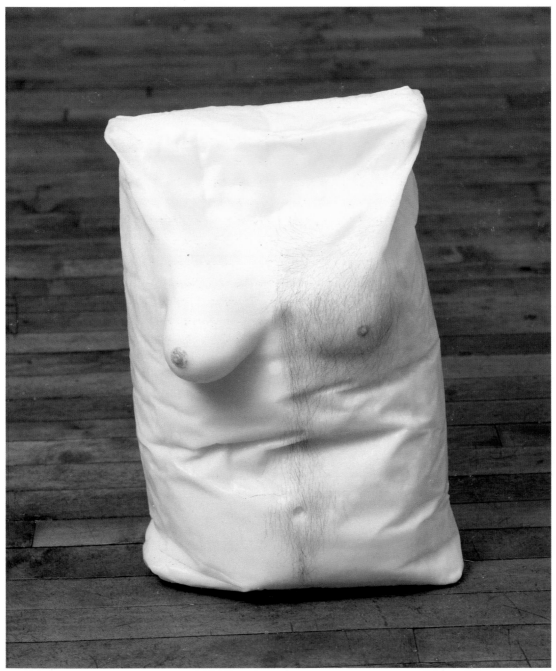

84
Robert Gober
Untitled, 1990
Courtesy of the artist
Private collection

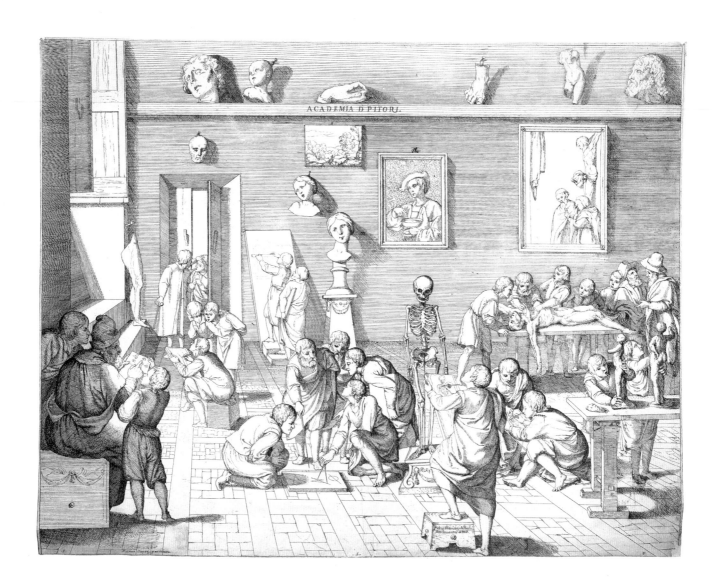

ACADEMIA D PITORI.

17
Pietro Francesco Alberti
*Academia di Pittori, c.*1600

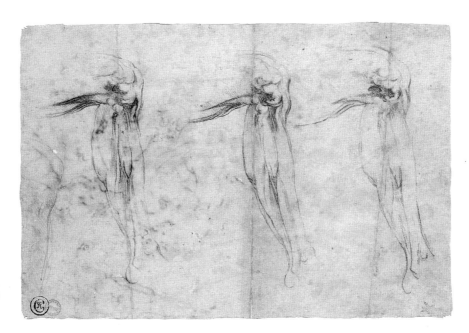

113
Raffaele da Montelupo
Anatomical and other
Studies, 16th century

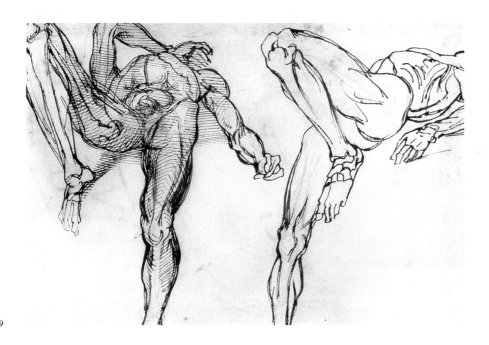

78
Théodore Géricault
Studies for *The Raft*
of the Medusa, 1818-19

not impede you, perhaps you will lack the good draughtmanship which appertains to such a representation, and even if you have skill in drawing it may not be accompanied by a knowledge of perspective; ... you might lack the methods of geometrical demonstration and the methods of calculating the forces and strength of the muscles...' (*Keele* and *Pedretti*, 1979, p. 362).

The combination of perceptual drawing skills and a strong stomach is evidenced too in the drawings of Théodore Géricault, who produced studies of severed heads and limbs for *The Raft of the Medusa*, 1818–19 (cat. 78). The spirit of these drawings is close to an expressionist engraving of heads by the surgeon/artist John Bell for his *Engravings Explaining the Anatomy of the Bones, Muscles and Joints* (cat. 31). When Ford Madox Brown needed to research a corpse for his painting illustrating Byron's *The Prisoner of Chillon*, he visited a dissection room and was horrified by a cadaver who looked like 'a wooden simulation of the thing' (cat. 37). Nevertheless, he ironically recorded in his diary for 13 March 1856: '... we... declared it to be lovely & a splendid corps[e]' (*Surtees*, 1981, p.167).

Although anatomists have studied their subject through drawing as well as dissection, and have often been considerable artists in their own right (cat. 54), they have usually employed an artist for published treatises. The pictorial anatomies of the 16th and 17th centuries were illustrated by professional artist-engravers, who worked in a number of different areas of print publishing, and the 18th century saw the rise of specialist medical artists such as Jan van Riemsdyk and Jan Wandelaar. Since the 19th century, specialist medical illustrators have worked with anatomists and illustrated publications rather than 'fine artists'.

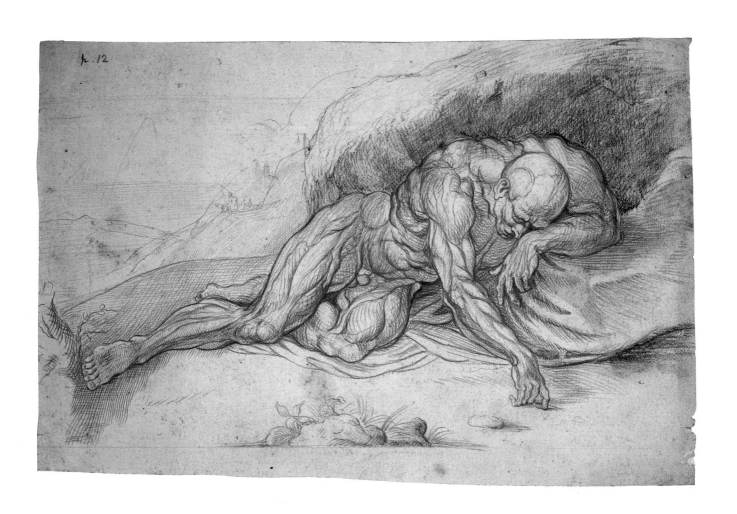

54
William Cowper
Resting écorché in landscape, 1705/10, from *Myotomia reformata*, 1724

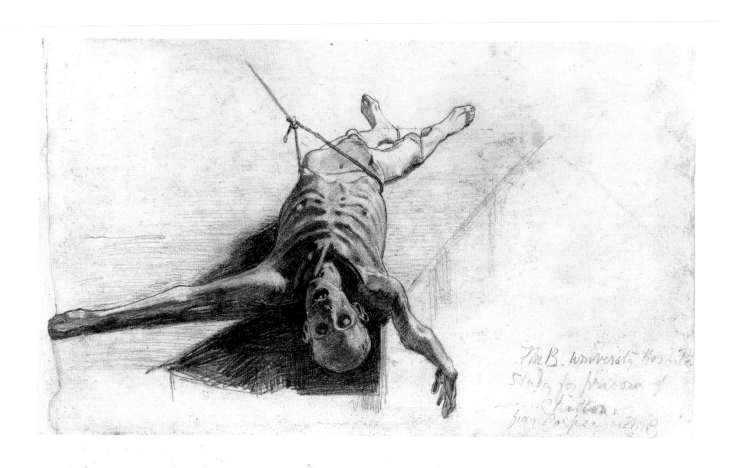

37
Ford Madox Brown
Study of a Corpse for The Prisoner of Chillon, 1856

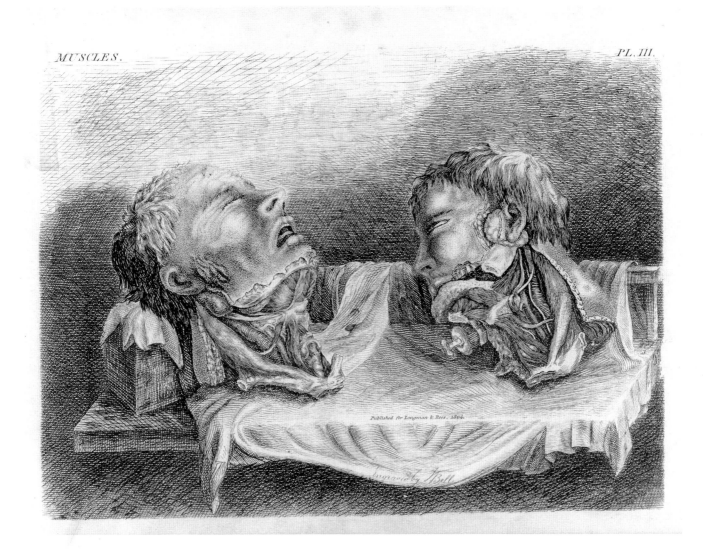

MUSCLES.

PL. III.

Published for Longman & Rees. 1804.

Engraved by J. Bell.

31
John Bell
from *Engravings Explaining the Anatomy of the Bones, Muscles and Joints*, 1794

122
Marc Quinn
Stripped Monochome (BW), 1997

The Skeleton in the Studio

Michelangelo and other Renaissance artists often made small wax models to define the musculature of particular poses, and bronze, stone or plaster écorchés of male muscle-figures became standard equipment in artists' studios and academies, alongside skulls and skeletons (cat. 160) (*Amerson*, 1975; *Arnason*, 1975). The skeleton was traditionally used in allegories of death, such as Albrecht Dürer's drawing of Death on an ancient skeletal horse (cat. 59), and the skull as the centrepiece of a *memento mori* still life lingers on even in the cubist still lifes of the early 20th century. But artists have also used anatomical images in a whole range of symbolic artworks dealing with religious or classical allegories of death. The subject of flaying for example, as in the stories of St Bartholomew or Apollo and Marsyas (cat. 136) (*Wyss*, 1996), was explored in the 16th and 17th centuries, the most famous example being Titian's *Flaying of Marsyas* painted in the 1570s and St Bartholomew holding his flayed skin in Michelangelo's *Last Judgement* fresco in the Sistine Chapel. Images of flaying have also been used as the frontispieces to anatomical atlases or in metaphorical representations of artists' academies (cat. 150). In Stradanus' (Jan van der Straet) brown pen and wash drawing for *The Arts of Painting and Sculpture*, 1573 (cat. 142), the crowded activities of an allegorical 16th-century studio include a bearded doctor with pebble spectacles solemnly completing a job of flaying on a suspended cadaver. The relationship of flaying to skin fetishism and notions of shedding identity has made this subject of interest again to a number of contemporary artists who work with body casts and synthetic materials, for example Marc Quinn (cat. 122).

A 16th-century interpretation of *The Vision of Ezekiel* (cat. 83) deals with the resurrection of bones: 'And I will lay sinews upon you and will bring up flesh upon you, and cover you with skin, and put breath in you, and ye shall live; and ye shall know that I am the Lord' (Ezekiel 37:6). This dictum is not far from that of Leon Battista Alberti, the early Renaissance architect and theorist: '... in painting a nude the bones and muscles must be arranged first, and then covered with appropriate flesh and skin in such a way that it is not difficult to perceive the positions of the muscles' (*Alberti*, 1991, p. 72). Raphael had

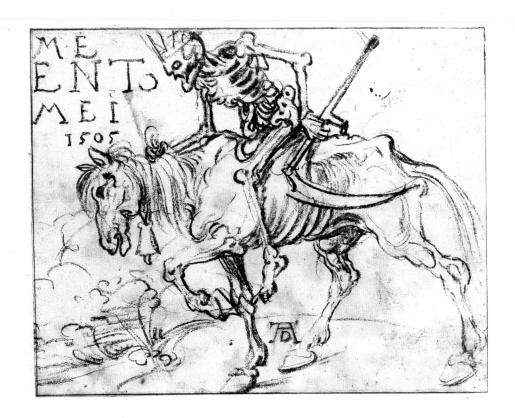

59
Albrecht Dürer
Death Riding, c. 1505

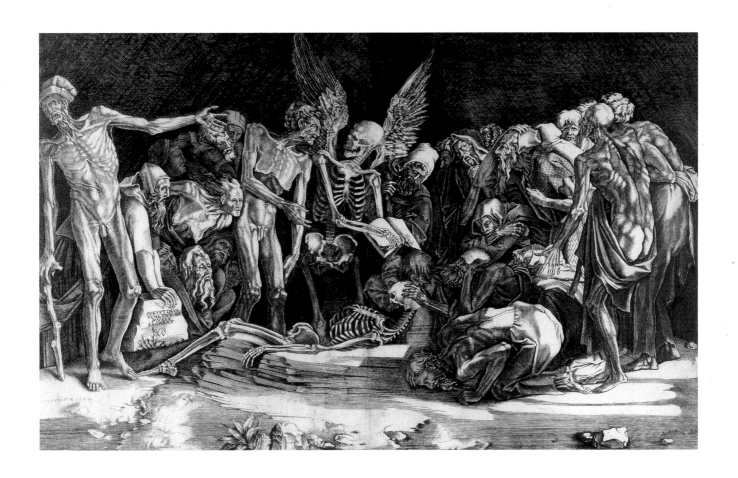

153
Agostino dei Musi, called Veneziano, after Rosso Fiorentino
Allegory of Death and Fame, 1518

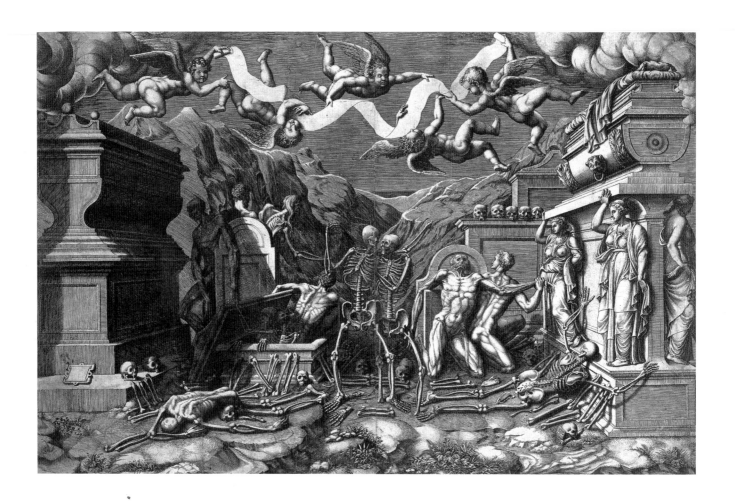

83
Giorgio Ghisi after Antonio Lafreri
The Vision of Ezekiel, 1554.

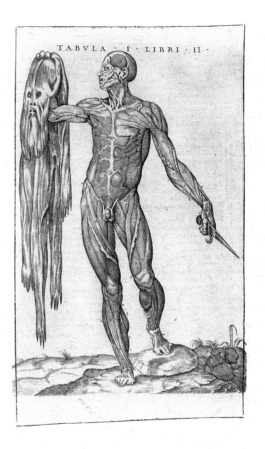

136
Giulio Sanuto
detail (centre panel) from *The Musical Contest between Apollo and Marsyas*, 1662

150
Juan de Valverde de Hamusco
Tab. I, Libri II from *La anatomia del corpo humano*, 1589

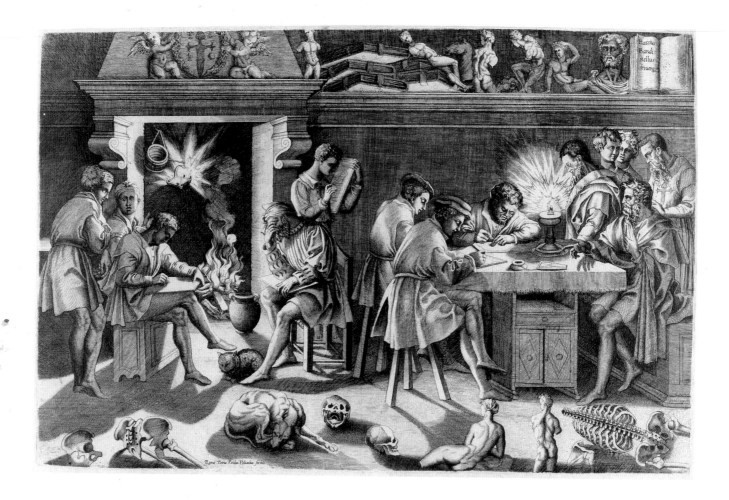

160
Enea Vico
The Academy of Baccio Bandinelli, c. 1535

142
Stradanus
The Arts of Painting and Sculpture, 1573

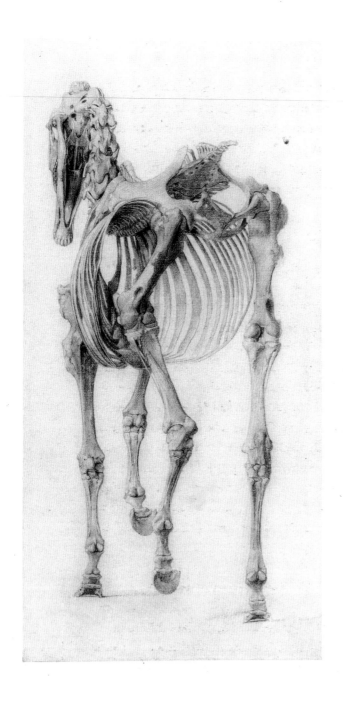

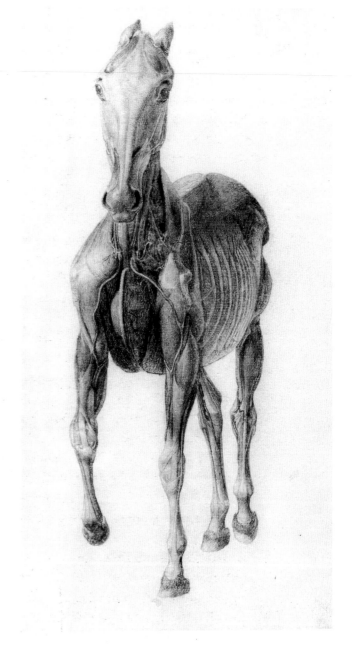

144
George Stubbs
from *Three dorsal views of the horse, progressively anatomised*
preparatory drawing for *The Anatomy of the Horse*, 1766

145
George Stubbs
from *Three frontal views of the horse progressively anatomised*
preparatory drawing for *The Anatomy of the Horse*, 1766

clearly followed Alberti's instructions in his *Anatomical Study of the swooning Virgin supported by two Holy Women* (cat. 123) for the Borghese Entombment of 1507. It is clear that George Stubbs was working this way in his studies of horse anatomy. Although his dissection follows the usual trajectory from the skin to the bone, in his drawings he fixes the muscles over a traced template of the skeleton (cats. 144 and 145). Knowledge, in this model, re-invigorates dead abstraction, and art breathes life into dry bones.

Animated Cadavers and Flap Anatomies

Within the rich and varied field of 'art and anatomy' certain visual tropes occur and re-occur over the centuries. One of the most persistent is the picturing of skeletons, flayed cadavers and partially-dissected bodies as if they are alive. These images are the subject of Baroque anatomies but originate in the illustrations to the great Renaissance anatomical textbooks of Andreas Vesalius of Brussels.[5] *De humani corporis fabrica* (the *Fabrica*) was first published in 1543 in Basel by Oporinus and illustrated by Stefan Calcar (Johann Stephan von Calcar) and possibly by Vesalius himself. Its shortened companion edition, the *Epitome*, with only nine illustrations, was published by Oporinus in the same year. The *Epitome* was organised so that two of the plates could be cut out and re-assembled over the skeleton figure as a 'flap' anatomy following the popular 16th-century tradition of 'fugitive' sheets. In these, hinged cut-out sections can be picked up successively to reveal the serial stages of the dissected body underneath. The tradition survives in popular paper anatomies of today, coloured variants of which hang on the walls of school, university and hospital classrooms. The skinned and layered figures appear to stand upright on solid feet, with their arms out, flashing a lively glance out of an exposed eyeball.

Animated skeletons dance through the pages of anatomical atlases from the 16th to the 18th century, but reach their zenith in the anatomical plates of Pietro da Cortona. The original drawings of this series, from around 1618, were acquired by William Hunter and are still in Glasgow University Library. The drawings, in black chalk, brown pen and ink, and whitening on grey-washed paper, were published in 1741 as the *Tabulae anatomicae*,

155
attrib. to Stephan Calcar
Weeping Skeleton, 1543
from Vesalius' *Fabrica*

108
Monogrammist RS
Interiorum corporis humani partum viva delineato, 1562/63

many years after Cortona's death. Not only do the partly anatomised figures pose like live models imitating classical statues on plinths in landscapes, but they also hold up framed images of larger-scale details, as pictures within pictures or mirrors (cat. 53). (The mirror, or *speculum*, which reflects an image back to the viewer, is a favourite device in Baroque art, but also plays an important part in medicine.) In Plate 27, a female figure holds open her own womb in order to display the uterus and urogenital system, while in a second view, a small infant sits in a tiny uterus, with its hands over its eyes. Equally bizarre images of reflexivity are also to be found in Valverde's (Juan de Valverde de Hamusco) *La anatomia del corpo humano*, 1589 (cat. 150), where a dissected man dissects another, and armoured breast plates are cut open to display intestines. In a group of anatomical books published in 1627 under the direction of Giulio Casserio, many of the illustrations are by Odoardo Fialetti, a pupil of Tintoretto.[6] In a muscle table from Spigelius *De humani corporis fabrica…*, 1627 (after Casserio) (fig. 1), an obliging cadaver holds up an abdominal flap to expose the musculature beneath, figured as a sort of internal 'corset' — a visual pun which artists were to use again and again. In a very unsophisticated 17th-century English copy of another plate by Fialetti, in John Browne's *Myographia Nova…*, 1698 (cat. 38), the artist has added a grin to the figure showing off his back muscles, as well as a pair of outsize legs and a cosy English landscape. In *Skeletal Group*, c. 1685 (cat. 110), by Crisostomo Martínez, a group of very urbanised skeletons socialise on a piazza of tombstones, with a frieze of bones on the frontal plane.

Dissection, Punishment and the Theatre of the Dead

The subject of dissection in the anatomy theatre is often used for the frontispiece image of anatomical textbooks. A clear outline woodcut, by a Venetian artist in the style of Andrea Mantegna, illustrates the lectures of Mundinus (Mondino de'Luzzi) in Johannes de Ketham's *Fasiculo de medicina*, 1493 (cat. 96). The woodcut depicts the mediaeval practice of a reading from a text while a demonstrator points to the relevant body parts of the cadaver.[7] The traditional elements appear in an English dissection scene of 1581 commemorating lectures by John Bannister, the *Mystery and Communality of Barbers and Surgeons of London* (cat. 86).

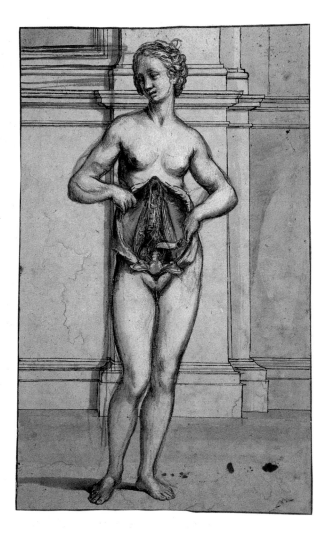

53
Pietro da Cortona (Pietro Berrettini)
drawings for plates 12 (left) and 27 (right) *c.* 1618, for *Tabulae anatomicae*, 1741

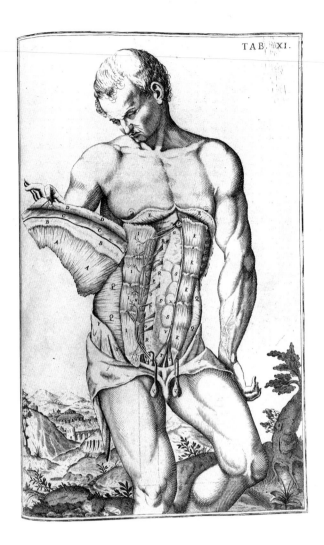

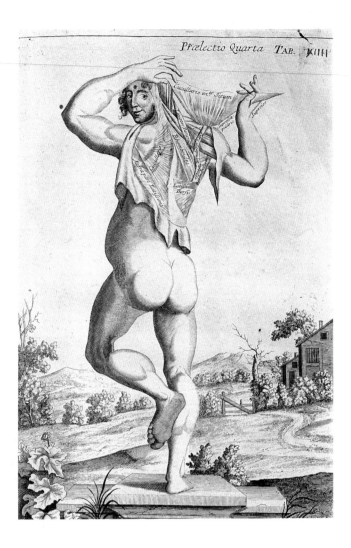

fig. 1
Spigelius Adrianus, after Casserio
Tab. XI, Book IV from *De humani corporis fabrica...*, 1627
Special Collections Department, Glasgow University Library

38
John (Joannis) Browne
from *Myographia Nova or a Graphical Deseription of all the Muscles in the Humane Body, as they arise in Dissection*, 1698

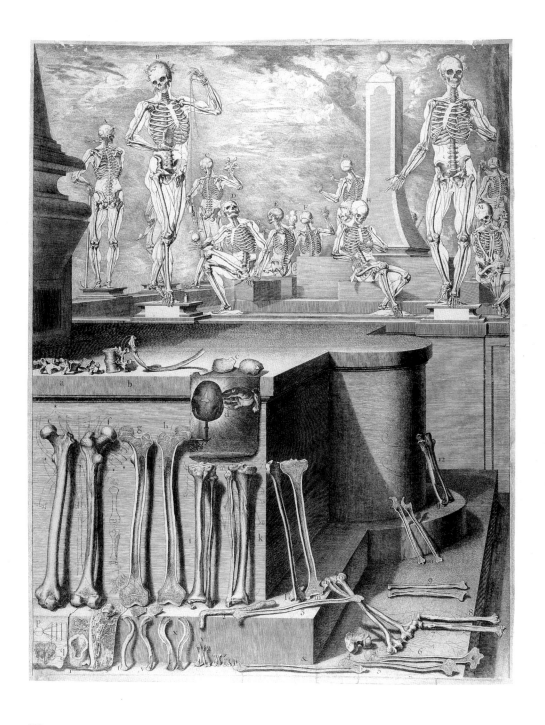

110
Crisostomo Martínez
Skeletal Group, c. 1685

The painting of the opened cadaver and the standing skeleton with its jolly striped barbershop head-bandeau retains much that is mediaeval and pre-Vesalian. Barbers and surgeons had been united into one company in Britain by Henry VIII in 1540, and were authorized to carry out dissections on executed felons.[8]

The title page of Vesalius' *Fabrica* shows a particularly potent image of a dissection, with its animated crowd of spectators watching the great anatomist as he indicates the opened belly of a female corpse (cat. 155). The scene is set within a circular architectural space with elaborate Corinthian columns and an ornamental frieze reminiscent of a church. Dissections were often carried out in churches in this period until the construction of special dissecting theatres. The first Dutch anatomy theatre at Leiden, constructed by Dr Pieter Paauw *c.* 1593, was often shown in engravings. It is usually depicted with skeletons of animals as well as humans, a central case containing surgical instruments, and often the Latin text *Nosce te Ipsum* (Know Thyself) which established the religious context for anatomical knowledge. The anatomy lesson became a subject for large-scale oil painting in Holland in the late 17th century, most famously Rembrandt van Rijn's *Anatomy Lesson of Dr Tulp*, 1632 (*Heckscher, 1958; Schupbach, 1982*).

The drama of the Vesalian frontispiece is recaptured in a dramatic etching in Jacques Gamelin's *Nouveau recueil d'ostéologie et de myologie…*, 1779 (cat. 71). Figures dressed as ancients in the style of Guercino gesticulate noisily within a semi-circular anatomy theatre.[9] The cadaver, however, has been displaced from the dissecting table and lies on the floor in an abandoned and sensual pose, as if it has just fainted, with a drape over the genital area. The association of anatomy and sexuality is a recurring theme through the centuries.

Until the 19th century, dissections were usually public as well as teaching events, which took place in winter in order to retard putrefaction and, in Italy, were sometimes held in association with Carnival (*Ferrari, 1987; Carlino, 1995*). As the corpses were usually those of hanged criminals, there was an implicit religious and moral association between dissection and punishment, a theme which William Hogarth was to exploit in the 18th

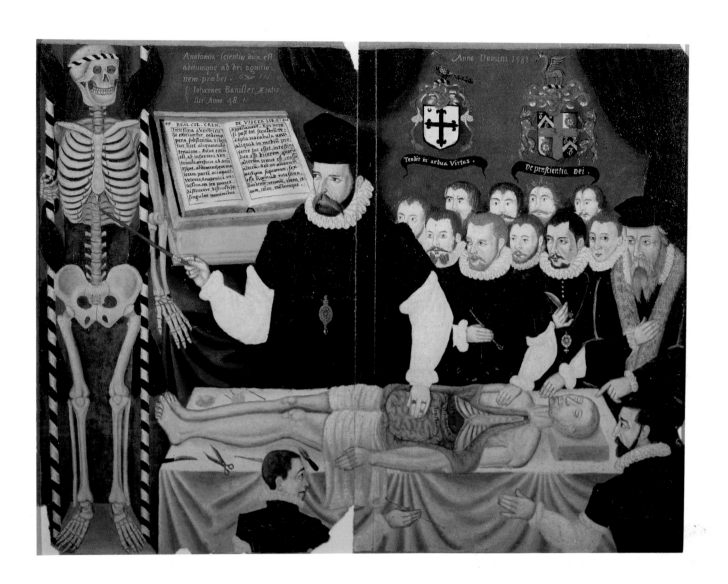

86
attrib. to Nicholas Hilliard
Mystery and Communality of Barbers and Surgeons of London, c. 1580
Dissection scene from a set of painted plates commissioned by John Bannister

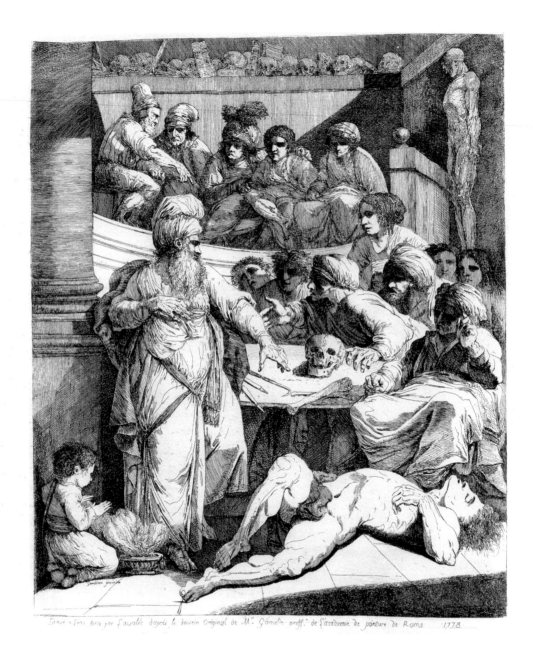

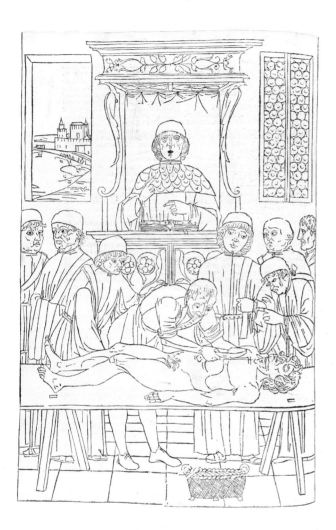

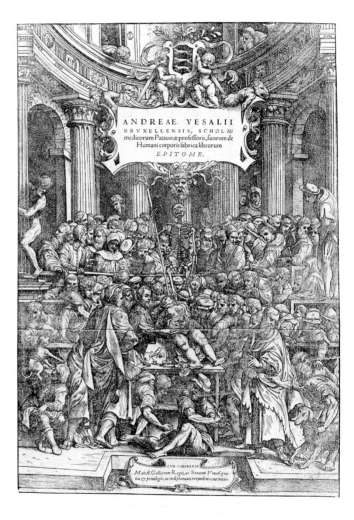

96
Johannes de Ketham
from *Fasiculo de medicina*, 1493

158
attrib. to Stephan Calcar, after Vesalius
An anatomical dissection being carried out by Andreas Vesalius..., 1543
title page to Vesalius' *Epitome*

century in *The Reward of Cruelty*. This woodcut is based (in reverse) on the last engraving of Hogarth's series of paintings and engravings, *The Four Stages of Cruelty*, 1751 (cat. 89), which depicts the stages of a criminal life. The anti-hero is hanged for murder and then suffers the supreme indignity of public dissection rather then Christian burial. The print includes the usual iconography of the anatomy theatre, if exaggerated and caricatured: the principal lecturer, the standing skeletons, the bucket for entrails under the dissecting table, dogs gnawing at bones (dogs are very prominent in Jacques de Gheyn's *The Anatomy Lesson of Doctor Pieter Paauw*, c. 1615 (cat. 81)) and even a cauldron for boiling the bones to assemble a teaching skeleton. Hogarth also makes much of the rope from which the unfortunate cadaver has been lowered, with its severed remains around the neck to remind us of the hanging which has brought about this cruel end. Ropes support some Vesalian muscle figures (cat. 155) and a rope holds the cadaver in Stradanus' *Arts of Painting and Sculpture*, 1573 (cat. 142). A rope makes a sinister appearance in the illustrations to John Bell's *Engravings explaining the Anatomy of the Bones, Muscles and Joints*, 1794 (cat. 31).

Living models also use ropes and pulleys for support in tiring or difficult poses. The connection between the flayed anatomical body as a text to be studied in the anatomy theatre and the live body displayed within the semi-circular arena of the drawing class has always been a potent, if subliminal, force in art. The layout of the anatomical theatre with its curved rows of seats in serried ranks is the model for the more modest plan of the life room and, in both situations, the best views were accorded to high-ranking academicians.[10] Karen Knorr deals with the formal architecture of Uppsala's historic anatomy theatre in her photograph *A Model of Vision*, 1994–97 (cat. 98), where her living model sits in the silent space of the absent cadaver.

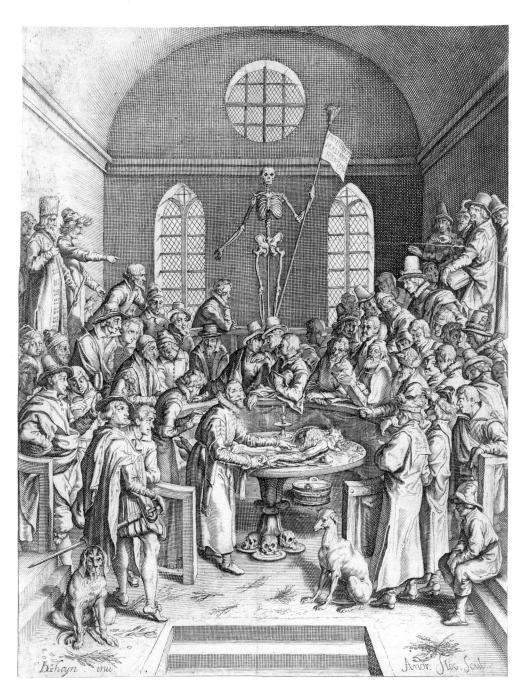

81
Jacques de Gheyn II
The Anatomy Lesson of Doctor Pieter Paauw, c. 1615
title page for *Primitiae anatomicae de humani corporis ossibus* by Pieter Paauw, Leiden

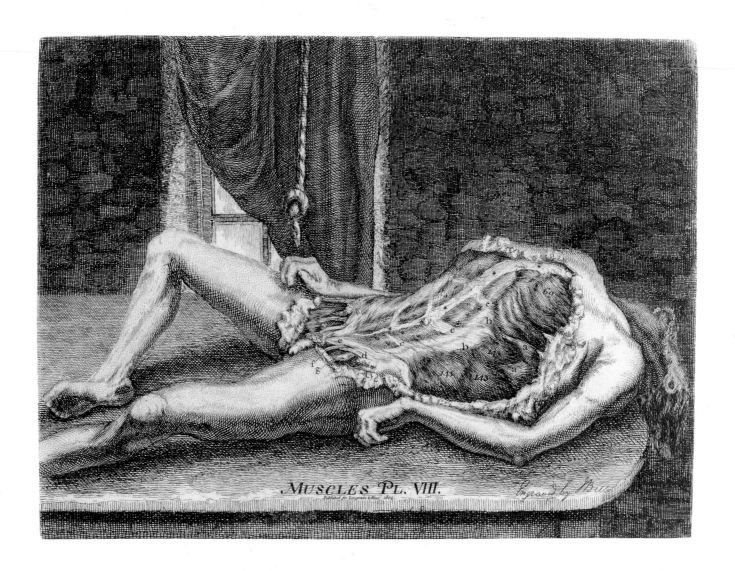

31
John Bell
from *Engravings Explaining the Anatomy of the Bones, Muscles and Joints*, 1794

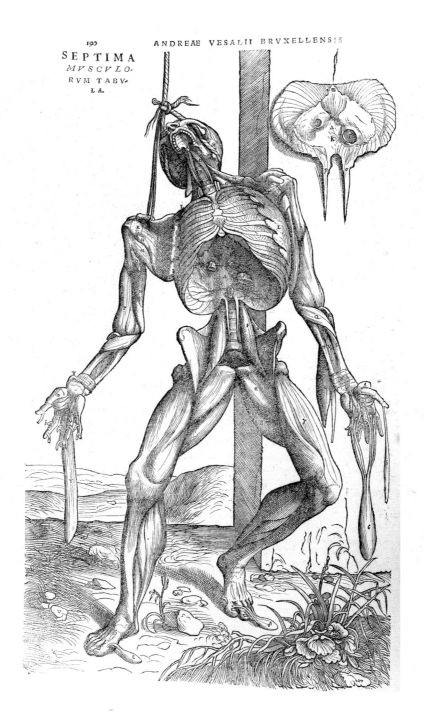

155
Andreas Vesalius
from *Fabrica*, 1543

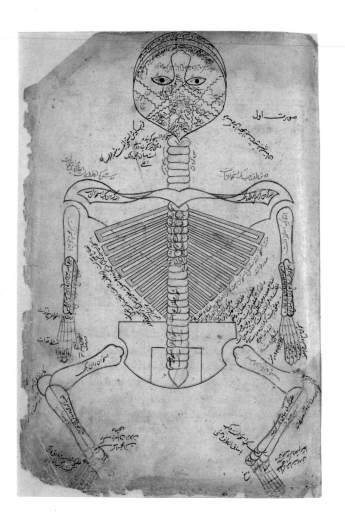

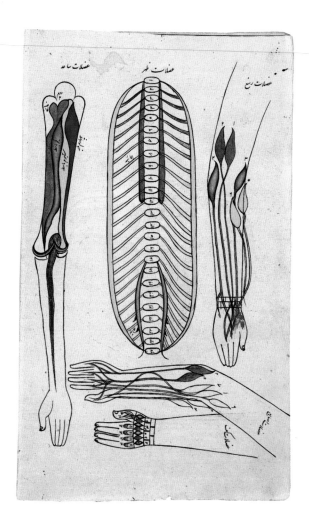

2
Anon
from *Tashrīḥ-i Manṣūrī*: The Anatomy of Mansur of Shiraz, 15th century

11
Anon
from *Tashrīḥ-i Manṣūrī*: The Anatomy of Mansur of Shiraz,
18th/19th century

Galenic Mediaeval and Islamic Anatomy

Leonardo da Vinci's earliest anatomical studies of internal organs grew out of traditional anatomy based principally on Galen (*c.* AD 129–199), whose work *On anatomical procedures*, preserved through Arabic translation, formed the basis of anatomical knowledge in the Middle Ages and had a considerable revival around 1500. Galen's knowledge of the human body was largely argued from analogy with animal anatomies, including the pig and the monkey. Mediaeval anatomical illustrators had used the convention of a linear outline of a body, in which internal anatomy was (more or less accurately) represented diagramatically on one plane. A figural outline convention was also sustained in the Galenic-based anatomical manuals (Tashrīḥ) of the pre-modern Islamic world, which employed a convention of five diagrams corresponding with the five 'systems' of the body – bones, nerves, muscles, veins and arteries (*Savage-Smith*, 1998). Muscles are not usually drawn but indicated by script forming ornamental flourishes in the corresponding part of the body, which is depicted, as in all the diagrams, in a half-squatting position. Manuals usually also contained a diagram of a gravid female with a foetus, and occasionally schematic diagrams of the eye. The skeletal figure from a 15th-century Timurid anatomical treatise, the Anatomy of Mansur of Shiraz, is viewed from behind, indicated by the convention of the upturned and upside-down head (cat. 2) (*Maddison* and *Savage-Smith*, 1997).[11] A remarkable undated Indian copy of a *Tashrīḥ-i Manṣūrī*, probably from the 18th or 19th century and possibly from the Punjab, contains muscular diagrams with a sparkling system of colour-coding within the clear outlines (cat. 11).

Leonardo da Vinci and the Grammar of Anatomical Drawing

Leonardo used an outline convention, a figure from Johannes de Ketham's *Fasiculo*, with its legs apart and arms out, when he charted the 'tree of vessels' in one of his very earliest anatomical drawings. But he soon improved upon this system, establishing a much more convincing visual transparency, so that we feel we are looking through a glass form into a fully volumetric three-dimensional model (something increasingly used in 20th-century

medical display.) Leonardo's studies in perspective and what he referred to as 'geometry' were essential in this respect. An early and very fine pen and ink drawing of sectioned skulls dated 1489 shows the accuracy of his observation in depicting the frontal sinus, which had not been previously 'discovered' (cat. 101).

Leonardo's anatomical studies stemmed from his fascination with the human body as the 'measure of all things' and his restless scientific curiosity which led him to investigate and make connections between the many aspects of the physical world as a macrocosm, which he entitled the 'terrestial machine'. He began his anatomical investigations in Milan about 1485 and returned to them during 1510 and 1511, drawing in notebooks with the text written with his left hand in mirror script.[12] The anatomical drawings and notes were intended for publication (the model was Ptolemy's *Cosmography*) and the pages include notes to himself on how to draw complex forms, proceed with dissections and make models to test systems. A remarkable facet of these amazing drawings is the way in which Leonardo invents strategies for representing the complexity of a dissection, so that one understands the successive stages of an anatomy and can also distinguish the forms of body parts and the functioning of bodily systems.

Leonardo simplified the immense complexity of veins and nerves, 'the very great confusion which must arise from the mixture of membranes with veins, arteries, nerves, tendons, muscles, bones and the blood which itself tinges every part...', making them easier to understand as systems, '... you will not see... more than a few vessels, to obtain a true and full knowlege of which I have dissected more than ten human bodies ...' (*Keele* and *Pedretti*, 1979).[13] By injecting wax into parts and veins in, for example, the brain of an ox, he was able to isolate forms and preserve them long enough to make highly accurate drawings. In order to render the action of joints and illustrate the location and power of musculature, he 'fenestrated' the muscles, that is, he showed the interstices between the muscular fibres so that the spectator can see how they overlap in depth, where they are attached to the skeleton, and how they activate movement. For even greater clarity he invented 'thread' diagrams, reducing muscles to single cords or threads (cat.103). In some

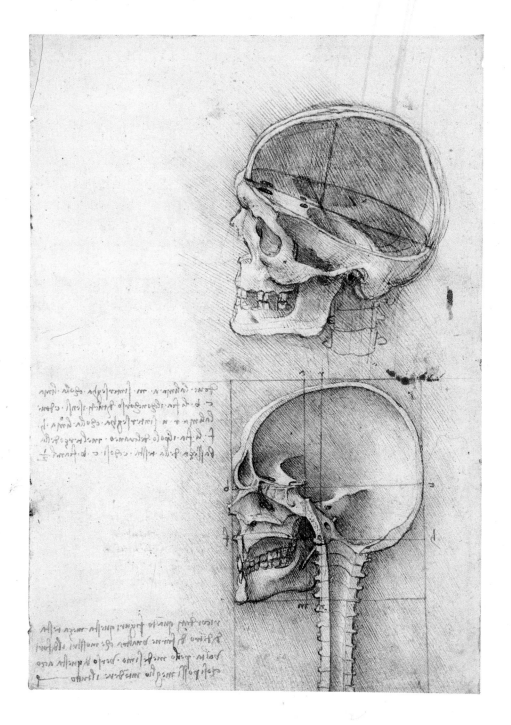

101
Leonardo da Vinci
Two drawings of the skull seen from the left, the one below squared for proportion. With notes on the drawings, 1489

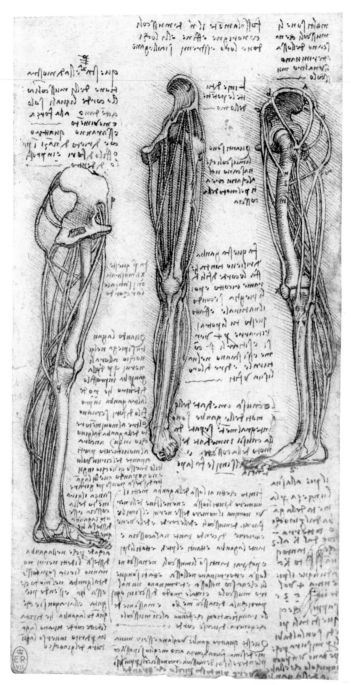

103

Leonardo da Vinci

Three drawings of the model of a left leg in 3 positions (profile left and right and facing) showing
bones with muscles and tendons being represented as copper wires; entire space filled with notes,
c. 1508-09

106
Leonardo da Vinci
Studies of the valves and sinuses of the heart, c. 1512-13

late works, these thread diagrams become very abstracted and mechanistic as he established the relationships between human form and structural engineering principles. Such principles are explored through sections as well as plans, and he developed systems of exploded and rotational views as '… an advantage for sculptors who have to exaggerate the muscles which cause the movements of limbs more than those which are not employed in… movement.' He also promoted the convention of drawing body parts and limbs from different viewpoints so that three-dimensional workings could be fully understood. The three-view system became established procedure for Renaissance artists, for example in the mannered drawings of Alessandro Allori.

Leonardo was concerned with the action of facial muscles on the expression of emotions, referring to the 'muscle of anger' and the 'muscle of sadness'. However, unlike the majority of artists before and since, he was equally interested in the functions and appearance of the internal organs and bodily systems, devoting much time to the study of optics, coition and embryology. He constantly drew analogies between the (hidden) forms of the body and principles in physics, particularly hydrodynamics in relation to the movement of blood. In the late drawing *Studies of the valves and sinuses of the heart, c.* 1512–13 (cat. 106), on blue paper, he sketches and gives instructions for making a glass model to study the movement of blood through the aorta. In a related drawing he suggests adding grass seeds to the experimental model in order to study how the flowing blood opens and closes the valve cusps.

Homologies of Male and Female Sexual Organs

Leonardo's drawings of reproductive systems rely on deeply ingrained beliefs in the 'homology' (visual and structural likeness) between male and female organs. In the drawing *Studies of the reproductive system, c.* 1508–09 (cat. 102), the male generative organ constitutes the model for the depiction of the womb which is shown with the ovaries at either side as a homology of the testes. The pre-modern identification between male and female organs, both in description and visualisation, is defined rather controversially by Thomas Laqueur as the 'one-sex model' and sustained its currency long after Leonardo (*Lacqeur*, 1986, 1989 and

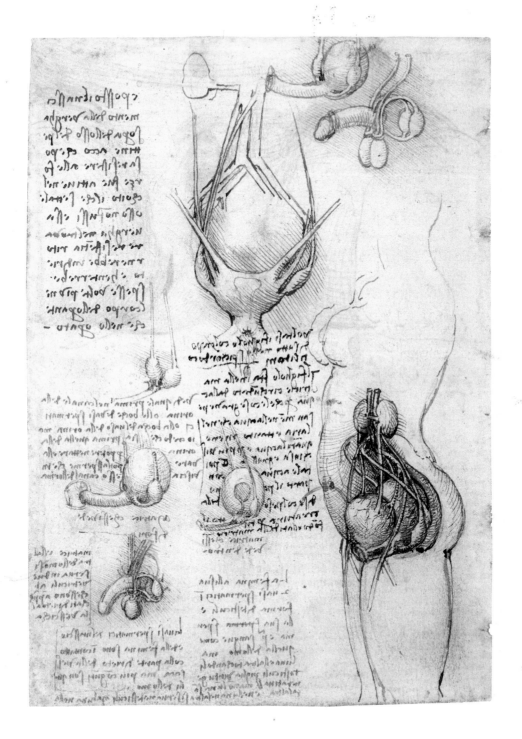

Leonardo da Vinci
Studies of the reproductive system, c. 1508/09

1996).[14] For example, Berengarius stated in his *Isagogae breves*, 1522 (cat. 34), 'the neck of the uterus is like the penis, and its receptacle with testicles and vessels is like the scrotum'.[15] Vesalius updated the anatomy of the sexual organs, nevertheless an illustration in Book V of the *Fabrica* depicts the canal between the ovaries and the vagina so as to look exactly like an internal penis. It is interesting that Vesalian sexual imagery should have persisted for so long. A rare anatomical painting from Iran, probably late 19th century, which is believed to have been for teaching purposes, reproduces Vesalian sexual organs on either side of the central figures. The gravida contains a tiny seated infant in the womb in the mediaeval European and Islamic tradition (cat. 12).

Leonardo's drawing also includes a uterus with three pairs of vessels entering it at either side, including hypothetical conduits carrying blood to the breasts to be converted into milk, and uterine tubes giving a 'horn-like' appearance to the uterus. A bi-cornate uterus appears in a number of German anatomies of this period including Walter Hermann Ryff's *Omnium humani corporis...*, 1541 (cat. 133), with illustrations by the artist Hans Baldung Grien. The persistence of such notions suggests that there are not visual 'truths' in imaging the body so much as culturally constructed representations. A bronze cast by contemporary artist Kiki Smith of the male and female *Uro-Genital System*, 1986 (cat. 138), presents a very different image which informs us of sexual *difference* rather than resemblance.

Cut and Paste Anatomies: the Copying and Transmission of Anatomical Material

According to the artist and historian Giorgio Vasari, Antonio Pollaiuolo, the early Renaissance artist, 'dissected many bodies in order to examine their inner anatomy, being the first to show the method of searching for the muscles to take form and order in the figure.' (*Vasari*, Vol II, 1987, p. 76). *The Battle of the Nudes*, c. 1480, the only existing engraving by Pollaiuolo, is a key image of the early Renaissance, establishing 15th-century preoccupations with muscular and expressive male bodies, nudity and the physical ideal. It is difficult to

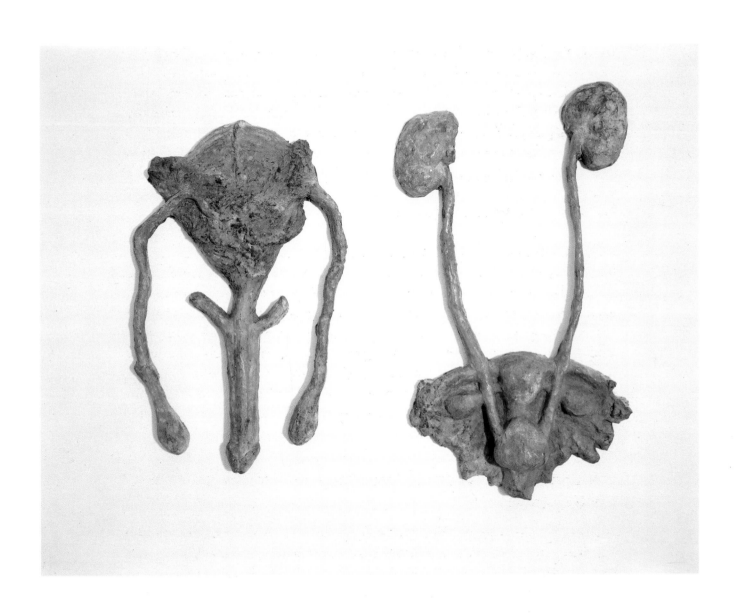

138
Kiki Smith
Uro-Genital System (male and female), 1986

VIGESIMASEPTIMA QVINTI
LIBRI FIGVRA.

PRAESENS figura uterum à corpore exectum ea magnitudine refert, qua postremò Patauij dissectæ mulieris uterus nobis occurrit. atq; ut uteri circunscriptionem hic expressimus, ita etiam ipsius fundum per mediū dissecuimus, ut illius sinus in conspectum ueniret, una cum ambarum uteri tunicarū in non prægnantibus substantiæ crassitie.

A, A. B, B *Vteri fundi sinus.*

C, D *Linea quodāmodo instar suturæ, qua scortum donatur, in uteri fundi sinum leuiter protuberans.*

E, E *Interioris ac propriæ fundi uteri tunicæ crassities.*

F, F *Interioris fundi uteri portio, ex elatiori uteri sede deorsum in fundi sinū protuberans.*

G, G *Fundi uteri orificium.*

H, H *Secundum exterius q̃ fundi uteri inuolucrū, à peritonæo pronatum.*

I, I *et c. Membranarum à peritonæo pronatarum, & uterum continentium portionem utrinq; hic asseruauimus.*

K *Vteri ceruicis substantia hic quoque conspicitur, quod sectio qua uteri fundum diuisimus, inibi incipiebatur.*

L *Vesicæ ceruicis pars, uteri ceruici inserta, ac urinam in illam proijciens. Vteri colles, & si quid hic spectādum sit reliqui, etiam nullis appos:is charactreribus, nulli non patent.*

s VIGE-

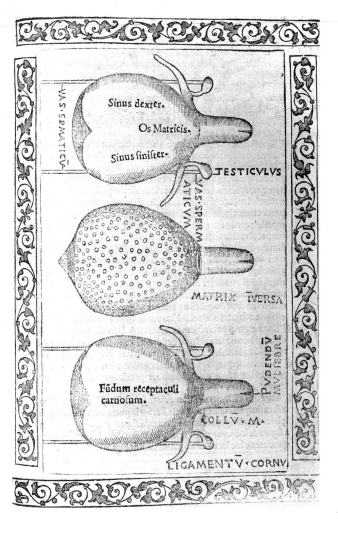

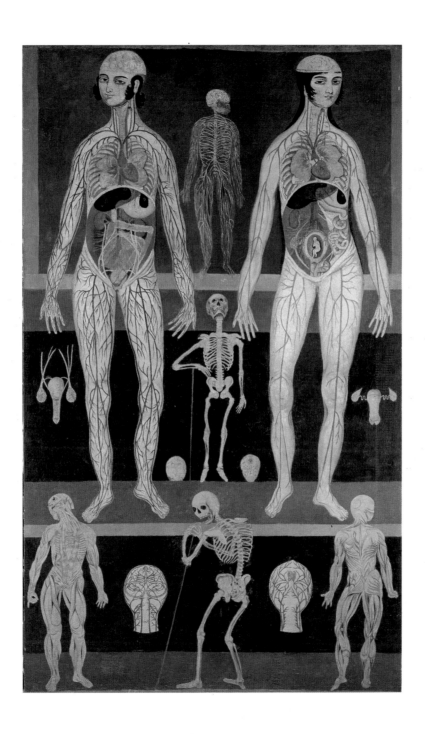

12
Anon
An anatomical painting, 19th century

establish whether the figures are wearing their skins or not! Many changes have occurred in the woodcut version of this iconic piece by a German print-maker, Johannes of Frankfurt (cat. 94). In his version the musculature has become even more fanciful, possibly due to imperfect knowledge and the transformations which are inevitable in copying. Due to the intense distinctions between light and dark areas of woodcut hatching, the 'original' has undergone considerable transformation. The whole area of anatomical imagery, both for artistic and medical purposes, depends on just such translations, re-interpretations and transcriptions of imagery and information. The potent woodcuts by Stefan Calcar for Vesalius have been copied the most, from their first appropriation by Nicolas Beatrizet for Valverde's *La anatomia...* and their engraved transcriptions by Thomas Geminus in Britain in 1545.[16] Vesalian imagery has even been set in wooden marquetry panels. With 16th-century works it is particularly difficult to establish which are the 'originals' and the 'copies' because the images themselves were part of a shared iconographic resource, attesting to the elaborate interrelationships of humanism and classical scholarship. Women are often shown in the *pudica* position of modesty (the Latin means 'shame') borrowed from classical Venus statuary, with one hand 'covering' a breast and the other concealing the pudendae or genital organs. The plate of a *gravida*, or pregnant female, in this posture from Valverde's *La anatomia...* is one of the fifteen additional images not plagiarised from the *Fabrica*. The source of anatomical illustrations often had nothing at all to do with anatomy and was even drawn from erotic engravings, such as the 16th-century series, *Loves of the Gods*, which existed in five copied sets. The reclining figure showing the penis and anal musculature in Spigelius' *De humani corporis fabrica...,* 1627, itself much copied, clearly relates to a reclining Venus figure surprised by Mercury in the *Loves of the Gods* series engraved by Gian Jacopo Caraglio (cats. 41 and 38). Many of the woodcuts for Charles Estienne's *De dissectione partium corporis humani...,* 1545 (cat. 65), rely on this source. Sexuality in these images is sometimes not entirely overt but suggested by the posture of a male leg over that of a seated female figure and of course the presence of a bed, which is perhaps also not out of place in a sickroom. A number of artists seem to have worked on the Estienne plates and in many of them one can clearly see how squares have been cut out of existing images and the anatomical details inserted. In instances where the female stomach opens

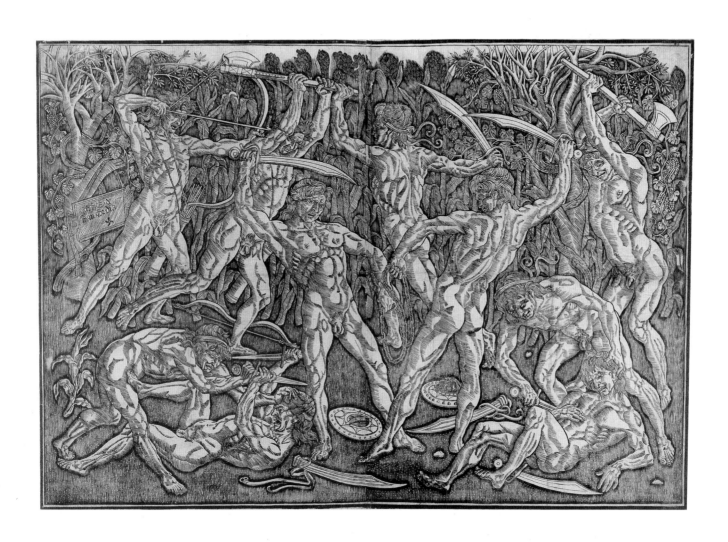

94
Johannes of Frankfurt after Antonio Pollaiuolo
The Battle of the Nudes, c. 1480

38
John (Joannis) Browne
from *Myographia Nova or a Graphical Description of all the Muscles*
in the Humane Body, as they arise in Dissection, 1698

41
Gian Jacopo Caraglio, after Perino del Vaga
'Mercury' from *Loves of the Gods*, c. 1530

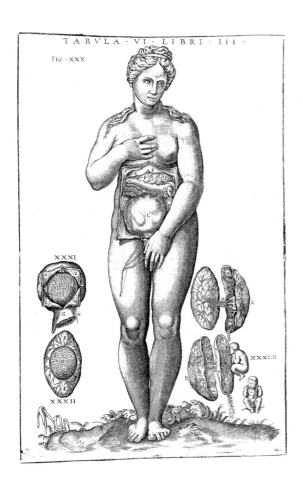

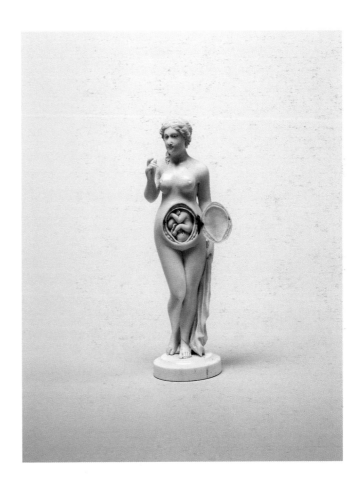

150
Juan de Valverde de Hamusco
Tab. VI, Libri III from *La anatomia del corpo humano*, 1589

10
Anon
Pregnant female figure, 18th/19th century

out like a little cupboard to reveal the womb or intestines within, this collage technique is particularly piquant (cat. 64).

Perhaps it is not surprising that one of the foremost exponents of 20th-century collage, Max Ernst, should have turned to anatomical manuals for some of his surrealist composite images, especially the collage novels of the 1920s and 1930s (cat. 63). Surrealist notions of the 'spark of contact' between bizarre juxtapositions fitted an appropriated quotation from Lautrèamont, 'As beautiful as the chance meeting on a dissecting table of a sewing machine and an umbrella' (*Lautrèamont*, 1868). 'Exquisite corpses' (*cadavres exquis*) was the name given to the composite drawings in the Dada and Surrealist game of Consequences. In Ernst's collage books without text, dissecting theatres, cadavers, écorchés, bones and body parts are mysteriously interposed in Victorian drawing rooms, as seamlessly interwoven as the irrational fragments of a dream (*Spies*, 1991). Contemporary Czech artist Veronika Bromová uses what she calls 'photo-surgery' in her composite photographs. Through the 'implantation' of anatomical areas collaged on to a photographed body using digital technology, she creates worrying images such as a shouting woman with her brain exposed (fig. 2) (*Bromová*, 1997).

The story of appropriation of anatomical images also involves passionate disputes and accusations of plagiarism. William Cowper, the English anatomist, appended a new text with no acknowledgement to the illustrations by Gerard de Lairesse for the famous work *Anatomia humani corporis…*, 1685, by Govard Bidloo, who published a bitter refutation (*Roberts* and *Tomlinson*, 1992, pp. 412–417). Lairesse's engraved illustrations are powerful and technically polished images of the stages of dissection, with realistic Dutch flourishes such as a buzzing fly, and the pins and blocks which were part of anatomical 'preparations' (cat. 56). William Cowper, however, was also a considerable artist in his own right, and his redrawings and additional plates to the second edition of *The anatomy of humane bodies…*, 1737 and his posthumous *Myotomia reformata…*, 1724 (2nd edition) take the Lairessian mannerisms to more expressionist ends. Cowper employs very little cross-hatching, and has a personal if scratchy linearity which was to have a profound influence on British anatomical artists, including John and Charles Bell (cat. 55).

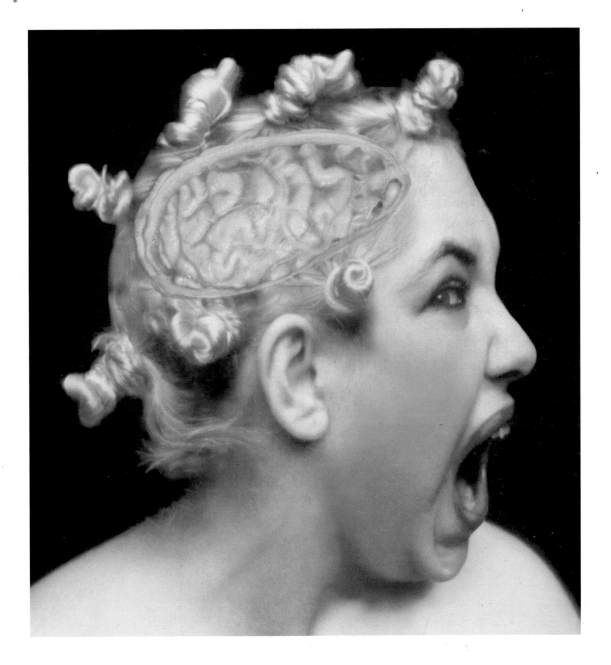

fig. 2
Veronika Bromová
Views, 1996
from the series *On the edge of the horizon*
colour digital photograph on a foam plate, 280 × 300 × 1 cm
© the artist 1997

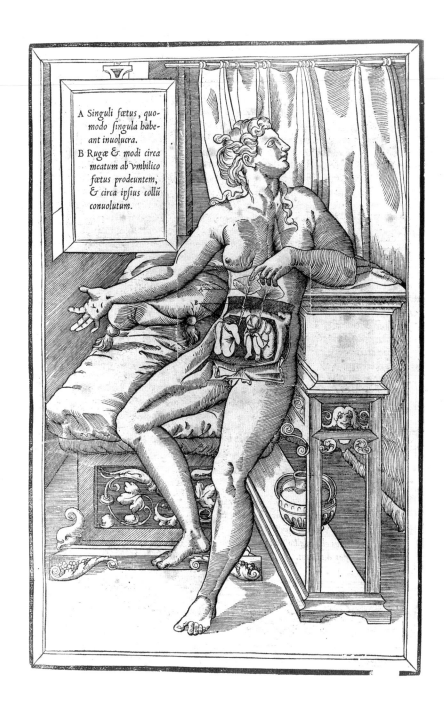

A Singuli fœtus, quo-
modo singula habe-
ant inuolucra.
B Rugæ & modi circa
meatum ab vmbilico
fœtus prodeuntem,
& circa ipsius collũ
conuolutum.

65
Charles Estienne
from *De dissectione partium corporis humani*, 1545

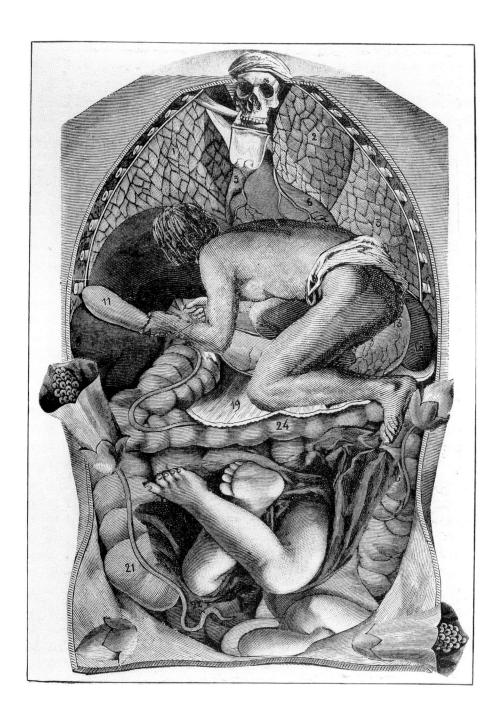

64
Max Ernst
from *Une semaine de bonté ou les sept éléments capitaux*, 1934

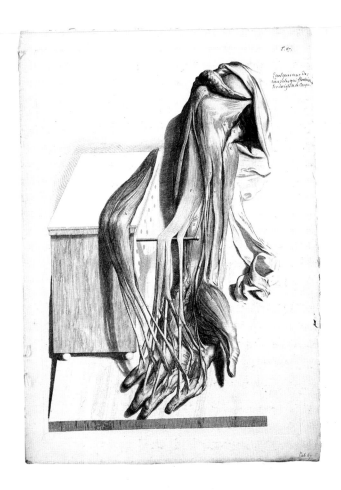

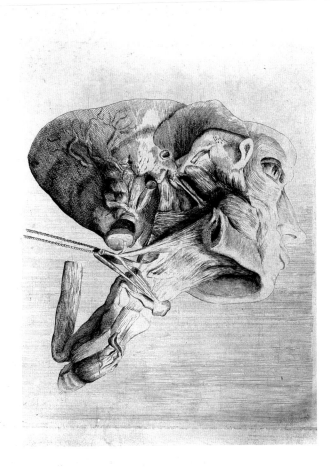

57
William Cowper, after Gerard de Lairesse
The flexor muscles of the lower arm raised through the use of a dowel and box, 1739

55
William Cowper
Elongated skull viewed from beneath from *Myotomia reformata*, 1724

The Politics of Mapping and Sexuality

Anatomical manuals are concerned with the 'mapping' of the body, which is perhaps why, since the 16th century, they have been called atlases. Leonardo designated one of his drawings *The Geography of the Heart*[17] and William Hunter declaimed: 'He may be said to be master of the *Anatomy* of the country, when he knows the figure, dimension, situation, and connection, of all the principal constituent parts…' (*Jordanova*, 1985, p. 395). As well as the spatial dimension, a pictorial atlas with its accompanying text is a serial publication, unfolding in time, just as a dissection is a series of staged representations moving from one state to another.

The organisation of material in anatomical atlases relates to profound philosophical and socio-medical discourses about the body. Most general anatomies do not follow the physical exigencies of the dissecting room, which traditionally began with the viscera and ended with the skeleton. Instead the organisation of the images reveals belief systems, for example, about the 'humours', or the location of the emotions or the soul. Leonardo located the 'seat' of the soul in the meeting of all the senses (*senso comune*) in the 'fulcrum' of the cranium. The exclusion of women's bodies from anatomical textbooks, except the specifically obstetrical, reveals the homocentricity of anatomical discourse, even in the 20th century. The male body is understood to be the 'universal' anatomical model, and homologies with the male body are physical as well as visual (*Schiebinger*, 1987). Even in the Renaissance theories abounded about the interchangeability of women's and men's body fluids; men 'menstruated', women exuded semen during coition. Sexual difference mainly resided in different body temperatures (*Bynum*, 1991; *Newman*, 1996). Body fluids, a taboo subject during the 19th and early 20th centuries, became the material of art in the 1970s and 1980s in response to feminist and psychoanalytical theory, for example, in the work of Helen Chadwick (*Grosz*, 1994).

Implicit in these various pictorial narratives is the notion of the whole body, either the visible starting point or the invisible summation of a process of fracturing. Today, human anatomy

has largely been replaced by the study of microstructures. The human body, as represented in contemporary 1990s CD-Rom pictorial atlases, is a sequence of radioscopic sections of ever greater reduction or magnitude, completely remapping the terrain of the body. Artists have responded to these new technologies: Mona Hatoum, for example, in *Corps étranger*, 1994, presents us with a voyage through the living, pulsating channels and orifices of her own body via the techniques of endoscopy. As Donna J. Haraway proclaims in her ironic 'Cyborg Manifesto' describing the effect new technologies have made on the social relations of sexuality and reproduction: 'These sociobiological stories depend on a high-tech view of the body as a biotic component or cybernetic communications system. … women's bodies have boundaries newly permeable to both "visualization" and "intervention".' (*Haraway*, 1991, p. 169).

Assemblages of Body Parts

Contrary to the holistic plan of anatomical atlases, artists' manuals are predicated on parts of the body. One such early book is the collection of etchings by Odoardo Fialetti, *Il vero modo et ordine per dissegnar…*, 1608 (cat. 67). As Fialetti was the illustrator of Casserius (and related anatomical volumes) there is a clear connection between the pictorial conventions of anatomical atlases and the increasingly popular artists' manuals. These manuals coincided with the foundation of artists' academies in Florence, Rome and Bologna. Agostino Carracci's didactic studies, created for the Carracci teaching academy in Bologna in the 1580s, were engraved after his death by Luca Ciamberlano.

The engraved artists' manual is a jolly assemblage of body members, a sort of conceptual kit-of-parts to be reconstituted in the studio. Manuals usually, although not invariably, begin with the head and the eyes, followed by rows of disembodied ears, noses, lips and profiles, then arms, legs, hands, feet (sometimes crowded into a virtual forest of limbs) and perhaps drapery studies. Occasionally there are full-scale drawings of male and female nudes or classical studies, comparable with the Vesalian 'Adam' and 'Eve' figures in the *Epitome*, 1543. In some books there are models of 'great masters' to be copied – usually a

67
Odoardo Fialetti
plate 4 from *Il vero modo et ordine per dissegnar tutte le parti et membra del corpo humano*, 1608

part of the body, such as a head vignette, rather than a whole composition. There are sometimes animals, particularly in the 17th-century Dutch manuals, and examples of facial expression ('the traits of human expression') became increasingly important.[18] The studies of expression by Charles Le Brun (fig. 3), one of the founding artists of the Académie Royale, were engraved and reprinted in many editions in the 17th century including Diderot's *Encyclopédie…*, 1751–1772. They became the basis of Lavater's *Essays on physiognomy…* translated from the German into many languages in the late 1780s, and even influenced the photographs of hysterics produced in the mid-19th century by the French neurologist Jean-Martin Charcot (*Callen*, 1995, pp. 54–55).

The manuals do not always contain anatomical information, though studies of écorchés are found in some Dutch and Belgian manuals, for example in the drawings engraved by Pontius after Rubens or in the Jombert edition of Rubens' drawings of 1773. Pontius transforms Rubens' drawings (presumably from a dissection) into wonderfully convoluted body parts with twisted, wiry and exaggerated muscles which have little to do with reality. Although Vasari is recorded as having written in desperation from Arezzo in 1537 to request the return of 'the book on bones and anatomy' as no corpses were available for study, special anatomies were being produced for artists by the 17th century (*Frey*, 1923-30).[19] Personal anatomical study sketchbooks, such as that of John Singleton Copley close to the engraved style of Bernardino Genga's *Anatomia per uso et intelligenza del disegno*, 1691 (cat. 76), make it clear that anatomical studies were more often made by copying the plates of printed anatomies than directly from dissections.

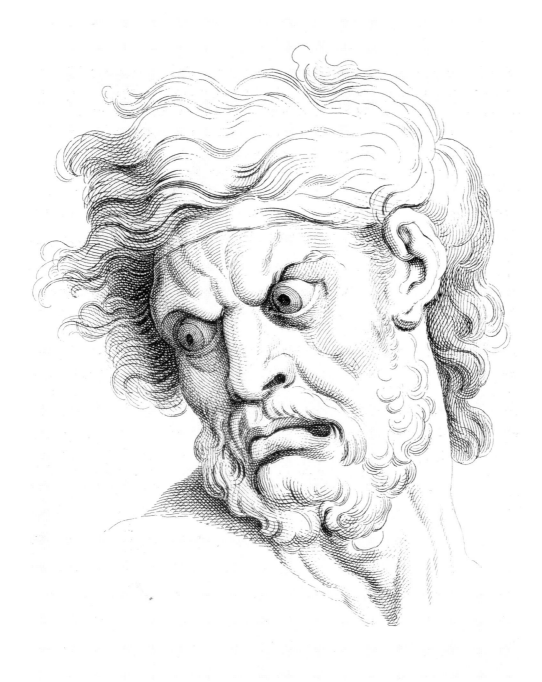

fig. 3
after C. Le Brun, *The face of a man in a state of anger*, 18th century
engraving
Wellcome Institute for the History of Medicine, London

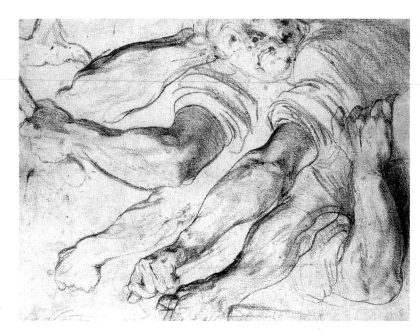

130
P.P. Rubens
Studies of Arms and a Man's Face,
c. 1616–17

67
Odoardo Fialetti
plate 27 from *Il vero modo et*
ordine per dissegnar tutte le parti
et membra del corpo humano, 1608

Classical Fragments, Dislocated Dolls and Anatomies of Stone

Broadly-etched versions of the headless, armless and legless Belvedere torso appear in Fialetti's drawing manual (cat. 67). Plaster casts of the fragmented torso became standard furniture for art students to practice observational drawing before moving on to the more 'advanced' stages of drawing from life. Although most study casts have now been thrown out of contemporary art schools in Britain 'The Torso' is still to be seen in all its inexplicable greyness and incompleteness in the Royal Academy Schools and Edinburgh College of Art. Just as the Vesalian 'Adam' is based on classical Herculean prototypes, so the Belvedere torso was used in the *Fabrica* in plates depicting the viscera. The same sculptural outline is used even more surprisingly in the plate which depicts a female torso with one flayed breast. A fractured body, which appears to be made of stone and yet contains muscles and soft organs, is so potent that it is used repeatedly through the centuries.

In the original Spanish version of Valverde's *La anatomia...*, 1589 (cat. 150), two hanging body cuirasses, apparently made of leather and metal, are opened up to display viscera in a bizarre variant of this convention. A single plate of a foot by Antonio Cattani of Bologna (cat. 43) conjures up associations with classical statuary, especially through the employment of a Greek fret design on the edge of a plinth. In representations of écorchés, an arm is often 'removed' in order to allow a clearer view of the musculature. In a late 16th-century engraving by Philips Galle, which is typical of this convention, the attached arm has been broken just below the shoulder in the 'antique' manner, while the appended arm floats behind the walking écorché, following its owner, so to speak (cat. 70). Visual amputations have been gleefully exploited in the 20th century, especially in the work of Picasso. Dolls with dislocated arms featured in the surreal images of Hans Bellmer in the 1930s and Herbert Bayer pictured himself in a photograph portrait of 1932 with an upraised arm separated from his body, and the missing slice held in his other hand (cat. 29). In the 1980s and 1990s many artists have worked with bodily dislocation and spare parts as a metaphor for social alienation and psychic loss. Cindy Sherman turned to a medical catalogue for the anatomical dolls with exchangeable genitalia and medical

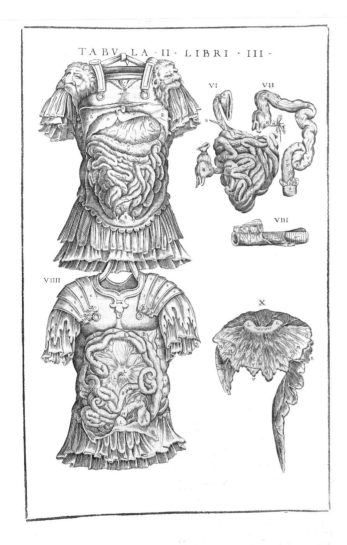

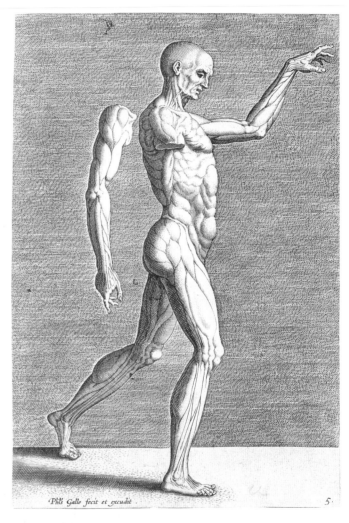

150
Juan de Valverde de Hamusco
Tab. II, Libri III from *La anatomia del corpo humano*, 1589

70
Philips Galle
Walking écorché, facing to the right, with detached arm, 16th century

9
Anon
Drawing of dissected foot showing tendons,
late 18th century

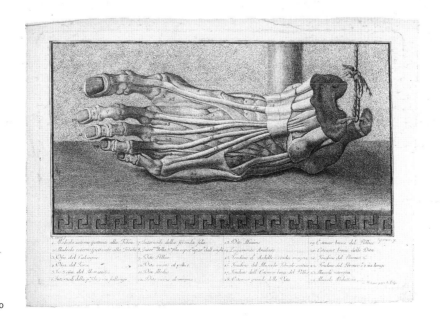

43
Antonio Cattani
Musculature of the Foot
from *Osteografia e miografia,* 1790

prostheses which she used in the 1992 series *Sex Pictures* (*Brehm 1996*) (cat. 137), which evoke the disturbing responses which Freud referred to as the 'uncanny'.

In his essay on 'The Uncanny' (*Das Unheimliche*), 1919, Freud begins with a reference to the doll/automaton, Olympia, in the *Tales of Hoffman*. He sees the uncanny as something which is secretly familiar but has undergone repression and notes how 'neurotic men (often) declare that… there is something uncanny about the female genital organs. Dismembered limbs, a severed head, a hand cut off at the wrist… all these have something peculiarly uncanny about them especially when… they prove capable of independent activity. … As we already know this kind of uncanniness springs from its proximity to the castration complex.' (*Freud*, 1985, p. 366). Perhaps the horror of the broken human cadaver needs its envelope of stone, which is simultaneously both natural and fabricated.

One of the bizarre aspects of the Western obsession with classical canons of beauty is the representation of the anatomy of statuary. The conceit is found in the *Anatomia*, 1691, by Bernardino Genga, which presents familiar and admired classical figures such as the Farnese Hercules, the Laocoon and the Borghese Gladiator as écorchés. Jean-Galbert Salvage's *Anatomie du gladiateur combattant…*, 1812 (cat. 135), places a skeleton and musculature (printed in red) within the outline of the Borghese Gladiator, engraved exquisitely by Jean Bosq.[20] Salvage, an army surgeon, discusses in his preface the difficulty of finding perfect cadavers to be fixed and dissected in the position of the Borghese Gladiator. A similarly gruesome exercise happened in the Royal Academy Schools, when a flayed cadaver of a hanged criminal admired by William Hunter was forced into the posture of the Dying Gladiator and cast in plaster by the sculptor Agostino Carlini. This figure, nicknamed 'Smuglerius', is still in the Royal Academy Schools and has been drawn by many, including William Linnell (cat. 107) (*Amerson*, 1976, p. 25).

The English surgeon William Cheselden's *Osteographia or the Anatomy of the Bones*, 1733 (cat. 50), much used by artists, included a skeletal Medici Venus and Apollo Belvedere. Cheselden instructed the engravers Gerard Vandergucht and Jacobus Schijnvoet to draw

137
Cindy Sherman
Untitled (#261), 1992
from the series *Sex Pictures* (*Brehm 1996*), 1992

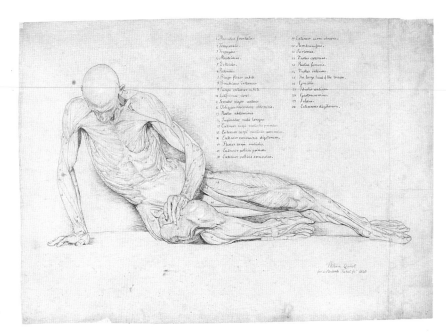

107
William Linnell
Écorché Study after Smuglarius,
1840

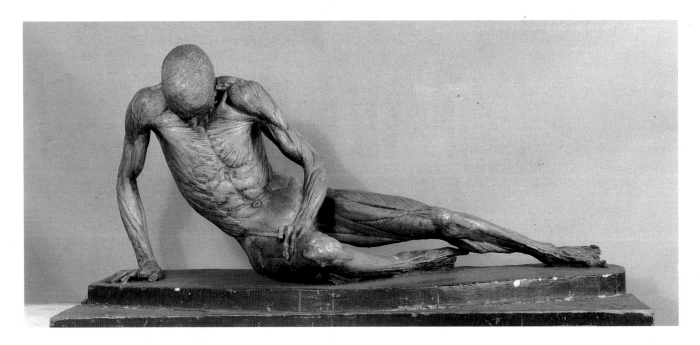

fig. 4
W. Pink, after Agostino Carlini
Smugglerius
plaster cast, 68 × 148.6 cm
Royal Academy of Arts

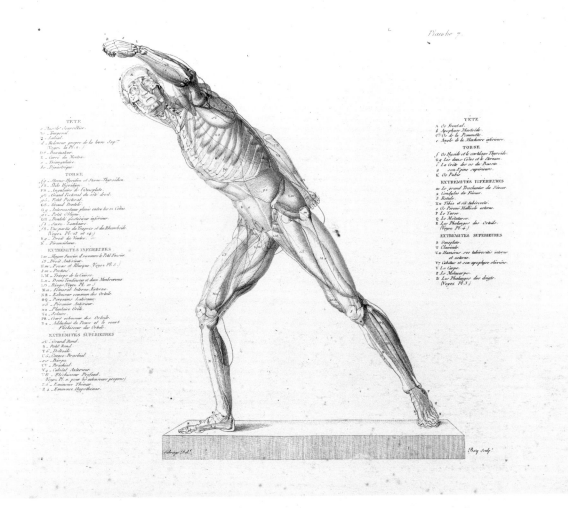

135
Jean-Galbert Salvage
from *Anatomie du gladiateur combattant, applicable aux beaux arts…*, 1812

with a 'convenient camera obscura' for greater accuracy. The camera obscura (forerunner of the camera) allowed the upside-down image projected onto its lens to be carefully traced on gridded paper, and could be fitted with magnifying lenses. The title page of the *Osteographia* contains a wonderfully ridiculous image of a figure peering into a particularly long and enormous camera obscura, while two other figures point to a legless armless torso, suspended upside-down from a tripod (fig. 5).

Perfect Proportion and the Static and Moving Body

The importance of accurate representation is the basis of one of the most famous anatomical atlases after Vesalius, the *Tabulae sceleti et musculorum corporis humani*, 1747, Leiden, by the Dutch anatomist Bernhard Siegfried Albinus and artist Jan Wandelaar. Albinus' obsession with exactitude began with a search for a 'perfectly' classically-proportioned body which was dissected, leaving the ligaments in place, strung up on pulleys and then drawn from three positions, with constant reference to a living model. To prevent the distortions of foreshortening, the figure was drawn through a series of grids (*Huisman*, 1992); full-scale drawings were then down-scaled for perfect accuracy. Albinus' pedantry must have been galling for Wandelaar, who was manipulated as much as the 'perfect' skeleton: '... he [Wandelaar] was instructed, directed, and as entirely ruled by me, as if he was a tool in my hands, and I made the figures myself' (*Albinus*, 1747). Nevertheless, the full-scale drawings in Leiden University library, in brown ink over chalk underdrawings, with washes and broad brush backgrounds, are most beautiful. They gain in intensity and clarity when reduced, and translate magnificently into the crisp black and white of the prints (cats. 161, 162 and 163).

The artistic and anatomical obsession with perfect proportion had begun in the Renaissance, and was understood to rely on the relative unit of measurement of head to body size. Fascination with proportion and number had exploded with Dürer in his so-called 'Dresden Sketchbook' and his *Four Books on Human Proportion*, 1528 (*Dürer*, 1528). Alberti had believed that there was one objective system of beauty, but Dürer, using a

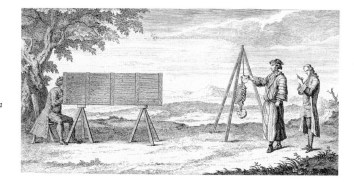

fig. 5
Gerard Vandergucht
A seated male figure looking through a camera obscura at half a skeleton suspended upside down from a tripod as two men look on
etching
Wellcome Institute for the History of Medicine, London

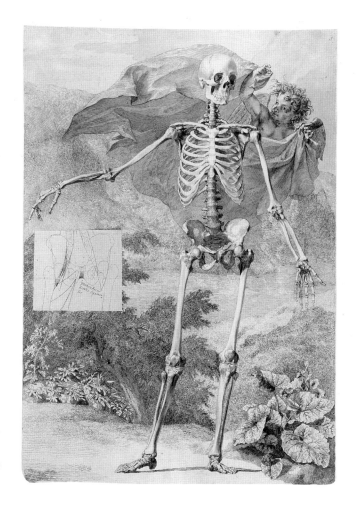

161
Jan Wandelaar
Preliminary drawing for *Tabulae sceleti et musculorum corporis humani*, 1747

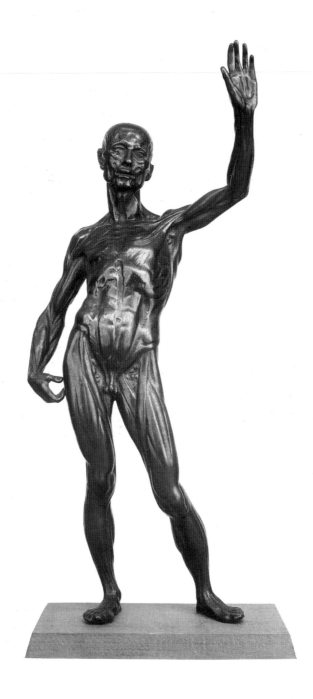

fig. 6
after Cigli
Anatomical figure, 17th century
bronze
62 cm (height)
The Board of Trustees of the
Victoria & Albert Museum

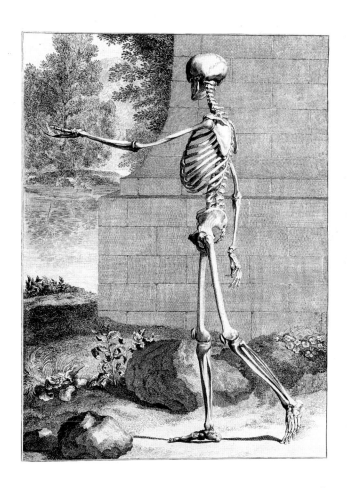

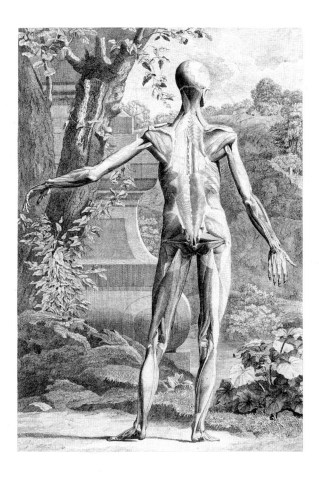

166
Simon François Ravenet the elder, after Jan Wandelaar
Male skeleton seen from the side, 1747
engraved plate to B.S. Albinus *Tabulae sceleti et musculorum...*, 1749
Tab. III of skeletal series

165
Charles Grignion, after Jan Wandelaar
Muscle-man seen from the back, 1749
engraved plate to B.S. Albinus *Tabulae sceleti et musculorum...*, 1749
Tab. VI of muscle series

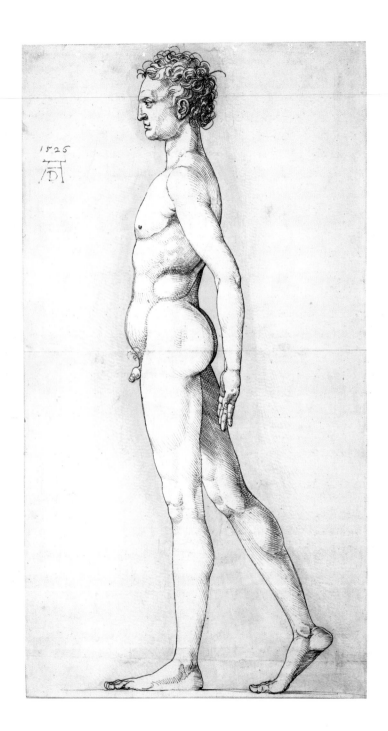

62
Albrecht Dürer
Study of a nude man walking in profile to the left, 1526

geometrical system of relative symmetry and harmony, played around with a whole series of proportions, widening, elongating and stretching his elasticated figures in the way they might be 'morphed' today by a computer drawing programme. Hogarth referred mockingly to Dürer in *The Analysis of Beauty* when he dismissed those who have 'puzzled mankind with a heap of minute unnecessary divisions' (*Hogarth*, 1753, p. 76).

In Gerard Audran's *Les proportions du corps humain...*, 1683, antique statues in simplified outline drawings bristle with measurements which perhaps add scientific legitimacy to the act of blind copying. The book was particularly popular in Britain, and Hogarth picks up on all these aspects of artistic training in Plate 1 of *The Analysis of Beauty*, 1753 (cat. 88) where even his own devotion to the undulating 'S' or 'Serpentine' line is satirised as a row of corsets. Hogarth reproduces a sheet of écorché legs on the left of the plate, which have been identified as drawings by Giles Hussey, the butt of particularly cruel attacks by Hogarth (*O'Connell*, 1984).[21] Hussey's relatively unknown album of drawings in the British Museum shows how he was indebted to Dürer's proportion-mania (cat. 93). The volume contains huge numbers of traced neo-classical outline drawings mainly in red chalk, obsessive profile heads buzzing with measurements and complicated notes on 'harmonic arithmetic', and a visual pun worthy of René Magritte. 'Canons' of measurement are incorporated into a proportional relationship between figures and upright military 'cannons'.

Bodily proportion, 'character' and movement are investigated in an unpublished notebook by John Flaxman known as *Motion and Equilibrium of the Human Body* (cat. 68).[22] In the first series of annotated pages, Flaxman examines the anatomical joints concerned with movement, which he charts through simplified, angular figures, which run, dive and carry weights. Since Leonardo, many artists had investigated the anatomy and the abstract dynamics of movement, often through stick-figures or block-diagrams. It was inevitable that speed and movement should become the subjects for exploration through the camera, and it is interesting to see how Eadweard Muybridge's photographs of movement grew out of a long tradition of anatomical studies (cats. 114 and 115).

The Tyranny of Measurement

The authority of measurement and bodily proportion takes on a more sinister dimension in the works of Pieter (Petrus) Camper and Samuel Thomas von Soemmering (*Camper*, 1794; *Soemmering*, 1797). They were both influenced by the aesthetics of Johann Winckelmann, who had proclaimed in his *Geschichte...*, 1764 that an attribute of beauty was 'the absence of individuality' and a 'harmony of parts... free from emotion' (*Winckelmann*, 1972). The posthumous *Works of the late Professor Camper on the Connexion between the Science of Anatomy and the Arts of Drawing, Painting, Statuary* was published in English in 1794 and included Camper's demonstration of an instrument for measuring the 'facial angle' (cat. 39). Camper's angle has been interpreted as the beginning of physical anthropology, but its application was not particularly benign. By collecting and comparing a range of skulls from 'eight different nations' he observed that 'a line drawn along the forehead and the upper lip, indicated... difference in national physiognomy' and he set out to prove Western racial superiority. Through a series of comparative head types, Camper demonstrated that the most beautiful lines and angles pertain to a classical Greek head, '... where the facial line makes an angle of 100 degrees with the horizon', whereas at the opposite end of the scale there was a 'degree of similarity between a negroe and the ape'. He was sure that 'there is no nation so distinguishable as the Jews' (by virtue of 'the crooked form of the nose'), that 'Calmucks', 'the representatives of all Asia' are 'the ugliest of all the inhabitants of the earth' and cannot walk perfectly upright because of the forward 'suspension' of their heads. In drawing comparative figures he dismissed the traditional schema of building up faces from an oval and proposed a system of grids and triangles for fixing the facial line and for delineating the different passions.

Camper's and Soemmering's theories about race and gender were part of the aesthetic and social debates of the time, but helped to lay the foundation for western discourses on racism. A powerful and dramatically-lit photograph by New York-based medical photographer Max Aguilera-Hellweg, of the head of a cadaver about to be measured with an elaborate apparatus, is carefully staged to suggest the sinister aspects of this device (cat. 16).[23]

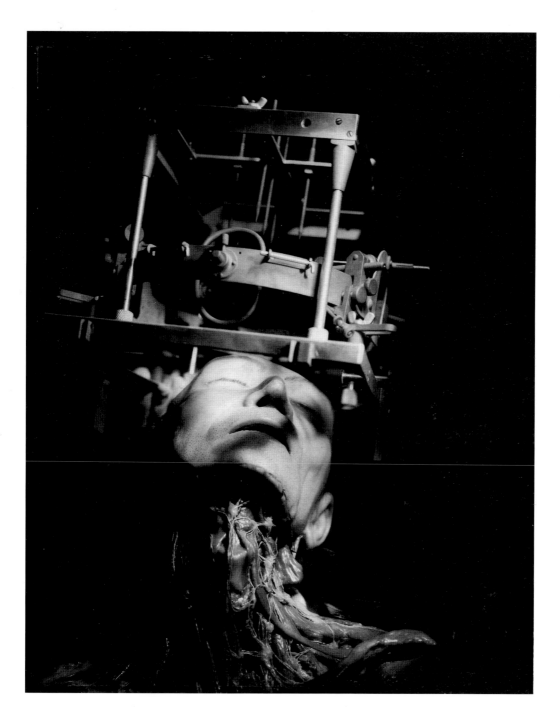

16
Max Aguilera-Hellweg
Untitled, (Spiegel-Wycis Stereoencephalotome, Model 2, with wax model demonstrating the lymph glands of the neck), 1995

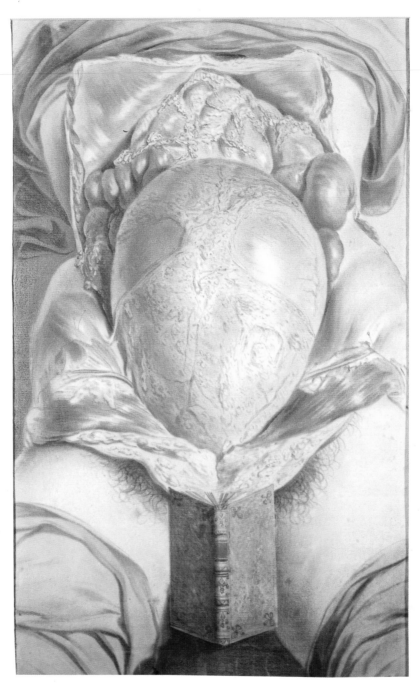

128
Jan van Riemsdyck
Tab. XXVI (front view of the womb)
drawing for William Hunter's *Anatomy of the human gravid uterus*, 1774

Imagos of the Fragmented Female Body

Soemmering published a specifically female skeleton, with the proportions of the Medici Venus, as a companion piece to Albinus' ideal male skeleton (*Soemmering*, 1797). He was not the first anatomist to do so: Chelsedon had published a female skeleton in 1733 drawn to the proportions of the Medici Venus, and drawings of a female skeleton by the French anatomist Marie-Genevieve Charlotte Theroux d'Arcouville had been published in 1759 (*Schiebinger*, 1987). The comparative anatomy of the sexes became very important in the 18th century, concurrently with new ideas about ideals of motherhood, the breast, breast feeding, female responsibilities for healthy practices and the relegation of women to a domestic and nurturing rôle in the home (*Jordanova*, 1985 and 1989). This was the period when members of the male medical profession took control of midwifery and the great British obstetrical atlases of William Hunter, William Smellie and Charles Nicholas Jenty were created. All of these volumes were illustrated by the Dutch-born artist Jan van Riemsdyck who also did drawings for the surgeon and anatomist John Hunter.

The drawings by Jan van Riemsdyck are amazingly powerful, not only for their subject matter but also in the confidence and beauty of their treatment. The drawings are very clearly done from real cadavers: in the preface to the *Anatomy of the human gravid uterus*, 1774, William Hunter describes how he procured the body of a woman who had died 'very near the end of her pregnancy'. For better and more lasting effect, wax was injected into blood vessels to keep their shape. The relationship in these images between the real and the idealised, the whole and the fragment, and what is represented and what is repressed, therefore invites complex readings. The absent body in most of these illustrations is represented by a ripped-out womb or section of the womb area, with sawn off legs, no upper torso or breasts and exposed pudendae. Occasionally a cloth 'veils' the dismembered limbs although, in the context of the sectioned cadaver, the cloth rather suggests 'unwrapping' (*Jordanova*, 1989). Similar cloths around the ends of limbs are used in 18th-century anatomical waxworks and to late 20th-century eyes are redolent with erotic suggestiveness rather than modesty. In Tabula XXVI of Hunter's *Anatomy of the human gravid uterus*, an

opened book is placed in front of the vagina to conceal it. As well as drawing attention to the very parts which it screens, the decoratively patterned book also signals the importance of the text in anatomical illustration, and possibly the power of the text in obfuscation of the visual (cat. 128). Infants in the womb (sometimes twins in the case of the Smellie series) are depicted as well-developed *putti*, rather than foetuses, in contrast to the dismemberment of the surrounding female bone and tissue (cat. 124).

The pregnant female body in Van Riemsdyck's images is suppressed in relation to the idealised representation of the infant. The mother is only marginally represented; she is a partial nurturing and delivering machine. More than a discourse on fetishism, these images evoke notions of the 'abject' female womb-body which, according to psychoanalyst and theorist Julia Kristeva, is as much related to perversion as it is to horror. Abjection is caused by 'what disturbs identity, system, order. What does not respect borders, positions, rules. The in-between, the ambiguous, the composite.' (*Kristeva*, 1982, p. 4). Contemporary responses to Van Riemsdyck's drawings for William Hunter must also be informed by the recent social debates which have surrounded Lennart Nilsson's carefully contrived photographs of foetuses. Nilsson's fragile foetuses, displayed in 1965 on the cover of *Life*, seemingly depict a translucent foetus attached to a partial placenta floating in a theatrically-lit 'otherworldly' space. There has been a substantial debate about the suppression of the mother's body in these representations, including suggestions that Nilsson colluded with American anti-abortion rhetoric about the rights of the unborn child and the consequent lessening of the mother's right to choice. Unlike the (possibly) prurient engagement in pudendae, pubic hairs and cut-open wombs of 18th-century images, Nilsson has dematerialised the mother's presence completely (*Nilsson*, 1965; *Newman*, 1996).

The Body as Spectacle

Van Riemsdyck is a spectacular technician and the simple means of red chalk suggests many different visual systems: signalling depth, differentiated textures (bone, subcutaneous fat, flesh), light and shade, implicated in the description of volume, and reflected on viscous

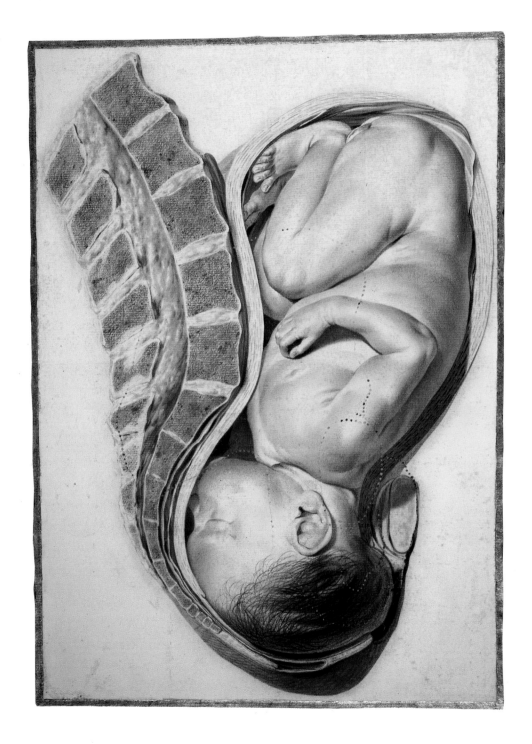

124
Jan van Riemsdyck
Foetus in profile, drawing for William Smellie, *A Sett of Anatomical Tables, with Explanations...*, 1754

membranes, glancing off intestines, or absorbed by soft tissue. Sometimes the red chalk is used dry and stumped; sometimes it has been 'painted' with the addition of water, giving a greater opacity and intensity of tone.[24] Sometimes the red chalk is erased to leave a patch of highlight, at other times white highlights have been applied. Occasionally a stipple effect is used, which is nearer to the effects created in printing. In some drawings, a brown wash is added and between grey, a yellowy mixed middle tone and intensities of red, the whole colour range of the incarnate body is suggested. Van Riemsdyck's drawings were printed in differing techniques in the various volumes, either in engraved versions or with all the intensity of black and white mezzotint.[25] In addition there was a beautifully-coloured version of the six plates of Jenty's *The demonstrations of a pregnant uterus at her full term*, 1757, printed in mezzotint on a single plate with the drawings in ochre, then hand-painted in gouache against a blue ground (*Rodari*, 1996, p. 133).

Jacques-Fabien Gautier (known in later life as Gautier d'Agoty) developed the revolutionary process of colour mezzotint which had been invented by his master Jacob Christoph Le Blon (*Rodari*, 1996). He used four colour separations which included black, but which were not quite as colourfully well-balanced as Le Blon's trichromatic system. Gautier d'Agoty, who initially worked with two anatomists, became entranced with his own scientific project and eventually performed his own dissections.

Gautier d'Agoty's plates *Muscles of head, eye and larynx*, 1746 (cat. 73) (from a demonstration by anatomist G.J. Duverney) and *Muscles of the head*, 1746 (cat. 72), give us something of the flavour of the uncanny in these coloured mezzotints. The upper bust in *Muscles of head, eye and larynx* emerges from its indefinitely-coloured, warm, cloth-like background with a spectral quality, as well as a solidity and curious stylisation – half classical bust, half real, not unreal – redolent with an uneasy presence.[26]

As far as is known, Gautier d'Agoty did not produce paintings, so the series in the Wellcome Collection (after d'Agoty) (cats. 74 and 75) is probably based on large-scale folding coloured mezzotints. The connection between death, eroticism and dissection is

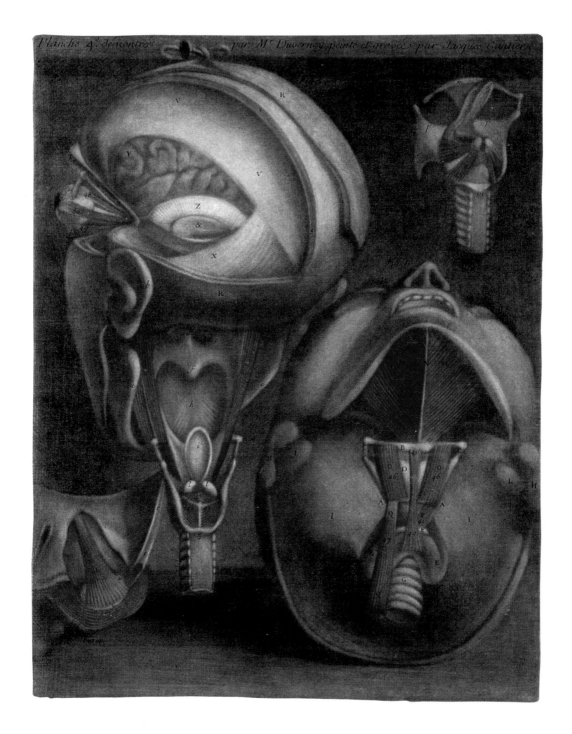

72
Jacques-Fabien Gautier d'Agoty
Muscles of the head, 1746

even more powerful here than in its earlier representation in Charles Estienne's 16th-century *De dissectione partium corporis humani...* (cat. 65). The entire gamut of visual permutations which belong to this area of representation is intertwined in these later images. The woman (cat. 74), with her belly open like a flower, as in Spigelius' *De formato foetu...*, 1626 (cat. 140), is seated with her skin as a stole, as provocatively as a nude woman at her *toilette* aware of being watched. The baby, wrested out of the womb, lies on her knee with its belly dissected: a mirror inversion. An écorchéd female sits behind, her vagina exposed to view: disempowered without her legs or arms. In the long panel on the left, a woman with her arms in the air turns to the spectator. Her body parts, including the emptied baby, are scattered around her. Her body is flayed, all except the face and breast – giving them a reverse sexuality, a mirror image of the sexual images in which a dressed women exposes her breast for male titillation. Gautier d'Agoty's images are produced for a male gaze. Sexuality here has been taken to its ultimate, and possibly fetishistic depths of penetration into the female body – beyond anatomy, beyond 'science'.

Anatomical Waxworks and Museums of the Grotesque

Gautier d'Agoty's images can be inscribed with complex psychoanalytical readings, but part of his professed aim was to create 'realistic' images in a pre-photographic age. This was also the intention of the Italian wax-modellers of the 17th and 18th centuries, notably artists such as Clemente Susini and Giulio Gaetano Zumbo, who made small and full-scale anatomical models for teaching purposes to supplement the limited supply of cadavers. They are housed in the museum of the Specola in the medical faculty of Florence University (*Lanza et al*, 1997). There was also a lively anatomical wax tradition in Bologna where Ercole Lelli was responsible for full-scale 'Adam' and 'Eve' figures and a series of progressively anatomised figures built up with wax over skeleton armatures.[27] In spite of their 'realism' the figures are very much of their period, with an unmistakable 18th-century classicizing flavour relating to the 'perfect' bodies of Albinus. Caryatid figures by Ercole Lelli, which were designed to support a wooden baldacchino (small roof structure) in the old Anatomical Theatre of Bologna University medical school, were also issued as

140
Odoardo Fialetti
Petal Venus, 1626
Tab. IV engraved plate for Spigelius Adrianus,
De formato foetu..., 1626

140
Odoardo Fialetti
Dissected infant, 1626
Tab. VIII engraved plate for Spigelius Adrianus,
De formato foetu..., 1626

74
after Jacques-Fabien Gautier d'Agoty
*An anatomical Virgin and Child: a seated
woman with open womb and foetus in her
lap, hand on breast*, 18th century

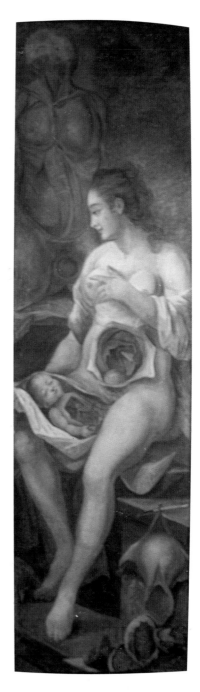

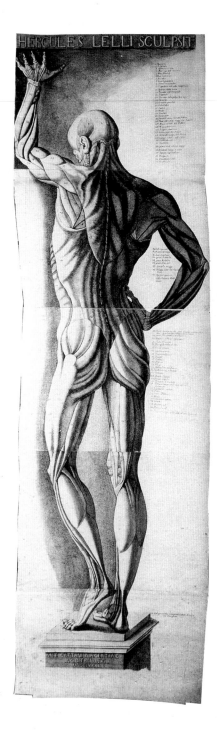

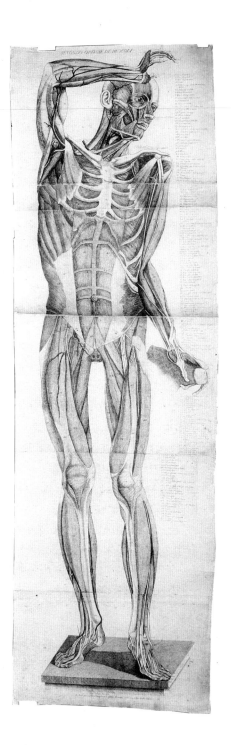

45
Antonio Cattani, after Ercole Lelli
Dorsal view of standing muscleman (as caryatid), 1781

46
Antonio Cattani, after Ercole Lelli
Frontal view of standing muscleman (as caryatid), 1781

engravings in a period when life-size fold-out anatomical prints were popular. An engraving by Antonio Cattani after Lelli depicting a dorsal view of the flayed caryatid has a harsh, metallic quality which creates an optical inversion: the inner body has become a hard carapace, reminiscent of science fiction (cat. 45).

Unfortunately, very few 18th-century British anatomical waxes survive in good order, but the models by Joseph Towne for Guy's Hospital give us some idea about how the tradition continued into the 19th century (cats. 146 and 147). Again, what is notable is the persistence of a classicising style within apparent hyper-realism. Anatomical wax techniques had come to Britain from France, which had a number of production centres, and Madame Tussaud was originally a purveyor of anatomical waxes. In France in the 1770s and 1780s, the military surgeon André-Pierre Pinson created over thirty human and animal waxes for the Cabinet of the (last) Duke of Orleans, which were rehoused in the Museum of Natural History after the revolution (*Lemire*, 1990).[28] Pinson's waxes are involved with the narrative sentiment of his period. The small-scale *Seated female figure* (cat. 119) coyly protects her face with one raised hand in the Christian *noli me tangere* (don't touch me) gesture as she shrinks from our gaze. However, her gaping abdomen displays the tabooed spectacle of her inner organs. To a contemporary gaze, these contradictions evoke suggestions of prurience, very like the Gautier d'Agoty women. The wax *Woman with a tear*, 1784 (cat. 121) is seen from one view as a classical bust with chestnut curls weeping for her own demise, whereas from the opposite side she displays a sectional head and brain.

Louis-Phillipe, who commissioned Pinson while he was still the Duke of Orleans, had inherited his cabinet of curiosities from his grandfather. Seventeenth-century Dutch anatomist and botanist Frederick Ruysch devoted most of his life to preparing wax-injected anatomical preparations. He mingled these with plants, shells and dismembered limbs in his amazing *wunderkammer*, which was bought by Tsar Peter the Great in 1717 and parts of which are still in St Petersburg (cat. 132).[29] William Hunter's brother John Hunter assembled a major cabinet of anatomical curiosities, medical and anthropological specimens as well as art works, now housed in a museum at the Royal College of Surgeons. Collections

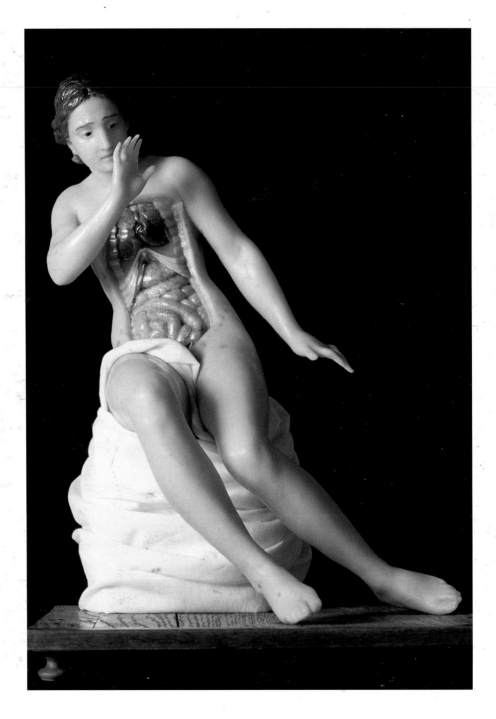

119
André-Pierre Pinson
Femme assise, anatomie de viscères (Seated female figure), end 18th century

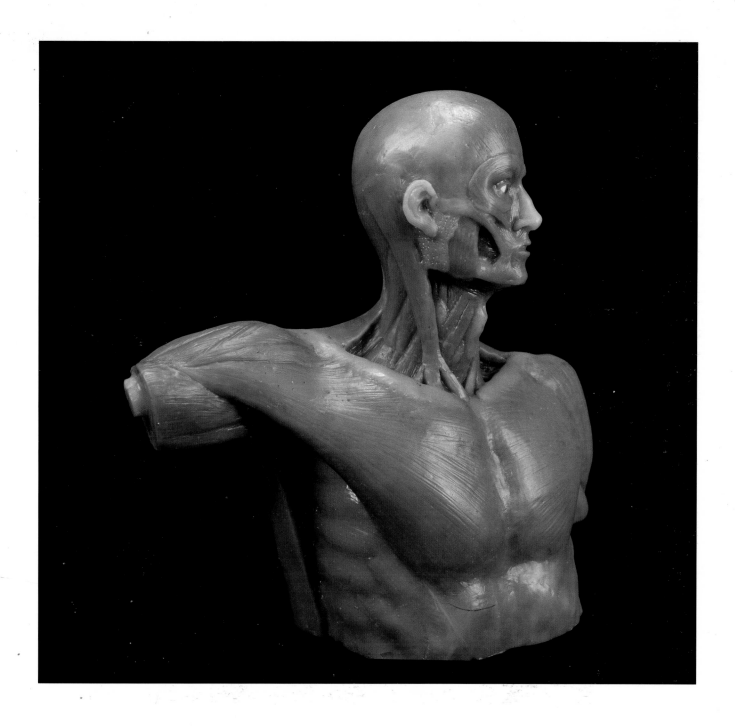

120
André-Pierre Pinson
Écorchéd trunk, end 18th century

like these have become of great interest to artists either obsessed with the grotesque or fascinated by the potent contradiction between the weird and the orderly, the transparent and the obscure. Zarina Bhimji deals with pickled specimens in her installation *We Are Cut From the Same Cloth*, 1995, which was part of a hospital commission, and American photographer Joel-Peter Witkin aestheticises taxonomies of horror in his sometimes shocking photographs of body parts and manipulated human freaks (cat. 171). He writes: 'I want to live in an age which sees similar beauty in a flower and in the severed limb of a human being. ... I photograph conditions of being, life and its logical extension... death (Schouten et al, 1989, p. 15).[30] The ethics of 20th-century medicine have determined that the anatomical body should only be displayed in a 'neutralised' scientific and scholarly context. Contemporary artists are deliberately challenging the professed dispassion of museological discourse and the taboos surrounding it, and are subjecting museological material to new kinds of public display within the aestheticised but critical space of an art gallery.

Traditional anatomy as a descriptive science is to some extent finite, and the charting of the body, which was not really completed until the 18th century, called for exacting and inventive visualisation. As doctors and anatomists were visually literate and often skilful drawers, and artists had a close involvement with the practice and presentation of anatomical imagery in their academies, collaboration of a very high order was possible. The influence of standard works such as Gray's *Anatomy*, which has never been out of print since 1858, served to mark the suppression of visual aspirations in 19th- and 20th-century textbooks intended only for use by the medical profession. Gray's *Anatomy*, with its dull engravings and layout and inconsistent additional plates drawn in various diagrammatic styles, legitimised notions of 'serious' science and powerful medicine unchallenged by the 'frivolity' of art. Anatomical material was appropriated by the medical establishment and it is only in recent years that medical history has established a *rapprochement* with cultural theory, and medical museums and libraries have become a resource for artists. New technologies and sophisticated science have meant new forms of visualisation such as magnetic resonance imaging and ultrasound scans so that the anatomical body is now visually permeable as never before. All these images are the stuff of multimedia presentation. Anatomical art for the millenium

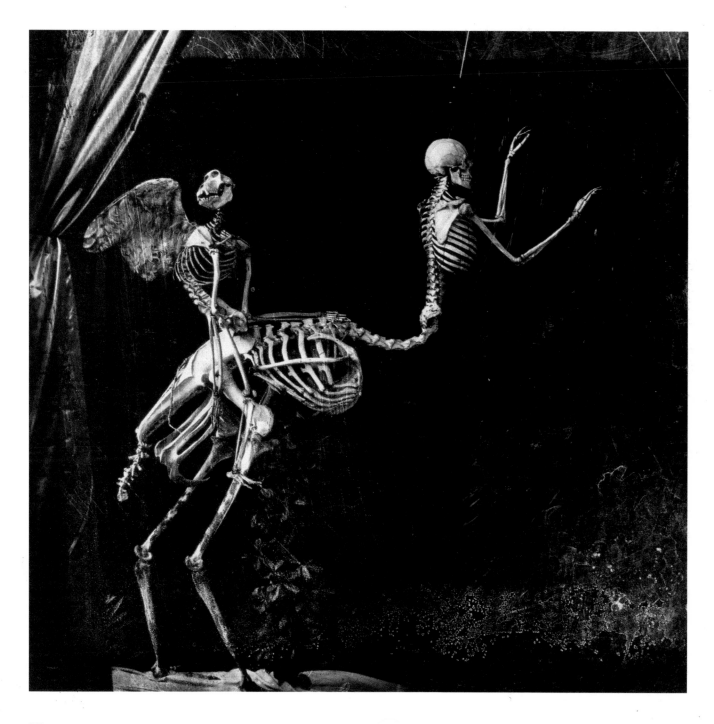

171
Joel-Peter Witkin
Cupid and Centaur in the Museum of Love, 1992

has already been hijacked by internet artists and the virtual images of the future are the anatomies of Cyborgs.

Notes

1 There are over a dozen écorché drawings by Michelangelo divided between the Royal Library, Windsor and the Teylers Museum at Haarlem.

2 Renaissance artist-anatomists recorded as having carried out dissections include Antonio Pollaiuolo, Luca Signorelli, Michelangelo, Alessandro Allori, Vincenzo Danti, Rosso Fiorentino, Lorenzo Ghiberti, Jacopo Tintoretto and Il Cigoli (Lodovico Cardi). Unpublished treatises include books by Michelangelo (rumoured), Rosso Fiorentino, Alessandro Allori and Pietro Francavilla.

3 A volume of satires by *Beckford in Biographical Memoirs of Extraordinary Painters*, 1780, refers to an anatomist 'Dr Blunderbussiana (*Lipking*, 1970, p. 160).

4 Realdo Columbo held the chair in anatomy at Padua after Vesalius and was one of the earliest authors to describe pulmonary circulation (*Condivi*, 1553, folio 42–43; *Cazort et al*, 1996 p. 113).

5 Andreas Vesalius (Andreas van Wesel) (1514–1564), who is often designated as the founder of modern anatomy, was born in Brussels, and studied in Louvain and Paris. In the late 1530s he was appointed to the chair of anatomy and surgery at Padua University, where his teachings were concerned with correcting the errors of Galenic anatomy, and asserting the importance of visual evidence and the practice of dissection over the inherited dogmas of ancient texts.

6 Giulio Casserio (c. 1552–1616) (Casserius) produced anatomical illustrations which were published after his death by the Dominican monk Daniel Rindfleisch, born in Poland and known as Bucretius (c. 1600–1631) who also studied in Padua. The Casserio illustrations were also used by Flemish-born Adriaan van den Sphieghel (Spigelius) (c. 1578–1625) who was Casserio's successor in anatomy at Padua, in his book *De humani corporis fabrica...*, 1627. Spigelius also produced *De formato foetu...*, 1627 with a limited number of plates by Odoardo Fialetti engraved by Francesco Valesio (*Roberts* and *Tomlinson*, 1992, 259–263).

7 By the 13th century, the four major European medical centres were Bologna and Salerno in Italy, and Montpellier and Paris in France, although the first legal dissection was only permitted at the Faculty of Medicine, University of Paris in 1407.

8 Inigo Jones' Anatomy Theatre for the Barber Surgeons was built in London in 1636.

9 The association with Francesco Barbieri (known as Guercino) (1599–1666) is apparent in the poses of the onlookers as well as in their oriental headgear. Guercino's *Livre de portraiture...*, in the French edition of 1642, was much copied.

10 The plan of Charles-Nicholas Cochin's *School of Drawing* in the Diderot and d'Alembert *Encyclopédie...*, under the entry of *dessein*, is very similar to Jacques Gondouin's neoclassical *Amphitheatre* built for the School of Surgeons, Paris, 1780.

11 Similar convetions appear in mediaeval western illustrations.

12 The majority of Leonardo's extant anatomical drawings are amongst the manuscripts in the Royal Library at Windsor, acquired sometime in the 17th century from Thomas Howard, Earl of Arundel. Although the drawings were studied in the 16th century, they were never published and were out of public view until 1636 when a few images were etched by Wenceslaus Hollar. William Hunter brought the drawings to public attention (*Kemp*, 1975 and 1976).

13 Notes to drawings RL 19061 recto and 113 recto.

14 The definition has been subject to critique, for example by Robert Martensen (*Martensen*, 1994).

15 The *Isagogae breves...*, 1522, by Giacomo (or Jacopo) Berengario da Carpi (Berengarius), is a digest of his large work *Commentaria... super anatomia mundini*, 1521, Bologna.

16 Published in Thomas Geminus' *Compendiosa totius anatomie delineatio...*, 1545, John Herford, London. 'Would that the books of the *Fabrica* with its *Epitome* had not been so shamefully and wholly spoiled by a certain Englishman...' wrote Franciscus, the brother of Andreas Vesalius in 1546.

17 19078 r.

18 Charles Bell wrote in the *Anatomy of Expression in Painting*, 1806: 'By anatomy... I understand not merely the study of the individual and dissected muscles of the face, or body or limbs... [but] the character of infancy, youth or age; the peculiarities of sickness or of robust health... the traits of human expression... the representation of sentiment and passion...'.

19 Such as De Pile's *Abrége d'anatomie*, 1668, dedicated to the French Royal Academy of Painting and Sculpture, and later Tinney's *Compendious Treatise of Anatomy, Adapted to the Arts of Designing, Painting and Sculpture*, 1743, recommended for students at the British Royal Academy of Arts.

20 The Borghese Gladiator, also known as the Discobolus, was brought to the Louvre in France from Italy along with other famous classical antiquities acquired by the Treaty of Tolentino, and was never returned.

21 Hussey's biographer relates how, when studying in Bologna Academy, he discovered such 'gross errors in... famous... statues' that he invented a sure method of trigonometry to demonstrate 'the faults, imperfections or defects in the proportions or in the perspective part of human bodies'.

22 This was either produced during his years in Rome between 1787 and 1794, or after 1810, when he was appointed Professor of Sculpture at the Royal Academy and gave a number of lectures on the subject.

23 A classic video piece by American artist Martha Rosler of 1977 (described as an opera in three acts) is entitled *Vital Statistics of a Citizen Simply Obtained*. Most of the film focusses on processes of measuring and remeasuring a nude female body, reducing the protagonist to the disempowered non-status of a numbered statistic. There are echoes here of the concentration camp, but also of the punitive power politics involved in 19th-century ethnographic photographs, or Charcot's photographic project involving hysterica and insanity.

24 A 'stump' is a spill of paper or a small twisted piece of leather used for spreading chalk into subtle and soft areas of tonality.

25 In the mezzotint process, a metal plate is given an overall surface treatment with a tool called a rocker, and the resulting 'burr' produces a deep velvety black when printed. Light areas are scraped down to remove the burr. This very laborious technique results in subtle tonalities and soft edges rather than abrupt tonal transitions.

26 Freud's notion of the uncanny was partly prompted by response to 'bleeding eyes' in *Tales of Hoffman*: '… an uncanny effect is… easily produced when the distinction between imagination and reality is effaced, as when something that we have hitherto regarded as imaginary appears before us in reality' (*Freud*, 1985, pp. 350 and 367).

27 The Bolognese tradition of building on to human remains – brought to a high standard by the female anatomist Anna Morandi – raises ontological questions about what constitutes a representation in this area.

28 Pinson and the French school combined both the practice of casting directly from a cadavre or live figure, and the preservation of cadaver parts through the injection of coloured waxes.

29 Rosamund Purcell's photographic researches indicate that several unlabelled preparations in the Museum of Anatomy and Embryology in Leiden can be firmly attributed to Ruysch (*Purcell* and *Gould*, 1993).

30 Witkin has attracted censorship and controversy; there is far more latitude towards picturing dismemberment in traditional media than in the 'indexical' photograph or film (*Mulvey*, 1975; 1996).

132
Frederick Ruysch
from *Thesaurus Anatomicus*, 1701–16

Happy Marriages and Dangerous Liaisons:
Artists and Anatomy

Ludmilla Jordanova

What brings art and anatomy together? The answers are at once very simple and highly complex, always returning to the human body as the richest imaginable source of interest and meaning. The cultures upon which *The Quick and the Dead* draws valued not just nature but naturalistic representation. The artists and anatomists who inhabited these worlds were drawn to the detailed study of the human figure, which has taken on a variety of forms – dissection, the life class, clinical observation, experiment, and so on. The history of these forms of engagement with human bodies is an elaborate one, and it is not my intention here to survey the range of ways in which, even at a given time and place, those people we call artists and those we call anatomists interacted. Sometimes, they were one and the same person. Generally, however, the dissemination of ideas and images of the body required elaborate collaborations not just between artists and those who studied the body from a medical and scientific point of view, but also with print-makers, wax modellers, sculptors, publishers, booksellers and with academies, hospitals, museums and galleries.

We need to start, however, with the human body itself, to acknowledge its status as a cultural resource and its capacity to be a place where many social constituencies can find meanings that are immediately relevant to them. This is possible because the body is simultaneously abstract and concrete, symbolic and intimate, familiar and dangerous, ordinary and mysterious, material and sacred. As anthropologists have long recognised, it is used in all societies for doing so much business – cultural, political, economic, religious – that its representations are everywhere, with the result that virtually everything seems relevant to understanding the body. However, the body is an extremely broad theme. It is helpful to have a more specific focus on art and anatomy and to recognise that both art and anatomy involve self-conscious discipline – in varying degrees intellectual, empirical, and

moral. The discipline is intellectual because art and anatomy have traditions of learning with which they are associated, which demand mental skills. For several centuries a knowledge of ancient languages and of philosophy was crucial for anatomists. At the same time art and anatomy were, until the 18th century, also understood as manual occupations, as crafts, which enjoyed a lower status than did purely intellectual endeavours. Nonetheless anatomists had classical medical texts where artists had the Bible, stories of exemplary religious figures, and ancient myth. Once both domains were professionalised, with their own institutions, state recognition and organised training programmes, intellectual frameworks were of enhanced importance and used to legitimate their new-found status as repositories of expert knowledge. The self-discipline of art and anatomy was empirical in that both groups looked carefully at, and sometimes probed the insides of, human bodies. What was found was tested and debated by others. Moral self-discipline was also involved in that there were constraints, particularly on what was represented, which were imposed not only by patrons, or by the limited availability of bodies to study, but also by less tangible forces, such as sexual convention: decorum is a powerful moral category. Thus both art and anatomy are disciplines aware of their own frameworks, even if at some periods the nature of these frameworks differed. Both were constrained in the manner in which they represented the human body, although the former has long permitted more free play than the latter. Indeed, especially in recent decades, medicine has supplied the materials with which artists can openly explore the troubling, unsettling aspects of bodily phenomena.

It is precisely because of its moral centrality that the body can so readily be used subversively. Showing parts previously concealed, or unfamiliar viewpoints, sexualised poses, explorations of decay and death can all have this effect. The disturbances invariably concern sex and death, sometimes both. These themes are integral to personhood, although certainly there have been marked historical changes in the way the self is understood and its relationship with bodily experience is construed. So much is apparent in a number of shifts: the contemporary preoccupation, especially by women artists, in revealing and re-presenting bodily phenomena; the huge impact of photography in making widely available a disturbing literalism; and the dramatic reconceptualisations of the kinships between

human beings and animals that have taken place over the last three hundred years or so, in which Charles Darwin played just one part.

Comparative anatomy, which visualises relationships between human beings and animals, was becoming a well-established scientific field over the last few decades of the 18th century. It paid particular attention to bones as these structures are the easiest to collect, study and depict, and form the scaffolding of the animals of most immediate interest to human beings: vertebrates. But long before the 18th century, humans were compared with animals in terms of their facial appearance and character. Renaissance physiognomies, existing as they did in a world suffused with the interplay between macrocosm and microcosm, found in people the look, the defining characteristics, of familiar animals – wolves, eagles, cows. Eighteenth-century natural historians, who were developing ever greater sophistication in classifying plants, animals, minerals and diseases, entered fierce debates on the defining characteristics of 'man'. Sometimes they turned to abstract mental qualities, the presence of a soul, the capacity for language or abstract thought, which were by definition invisible. Artists and anatomists, however, shared an interest in *visible* structures. The skeletons, organ systems, and outward forms of human beings and animals were being compared by early comparative anatomists. These could be presented in series, as, for instance, in the case of Lavater's famous depiction of a sequence of heads, from a frog's at one end to Apollo's at the other, or Camper's sequence from an ape's head to that of a human, yet without a trace of an evolutionary perspective in the 19th-century sense (cat. 39). These are not forms that have, over aeons of time, developed one from another, but a visual pattern and a framework through which to organise and classify organisms in terms of their degree of perfection.

Indeed, bodies could be understood in various types of series. For example, one can display the life cycle of a species, starting with the most rudimentary form visible, and ending with the new being (cats. 32 and 33). Here, time is the relevant variable, and time on a scale that is easily apprehended by human beings, quite unlike the vast epochs that had to be conceptualised in the 19th century, which developed the notion of 'deep time' (*Rudwick*, 1992). Visualising the human life cycle involved its own kind of depth, as is evident from

39
Pieter Camper
from *The works of the
late Professor Camper
on the Connexion between
the Science of Anatomy
and the Arts of Drawing,
Painting, Statuary*,
1794

33
William Bell for John Hunter
drawing for *Incubation of the chick*, *c*. 1782

21
Saint Aubin for John Hunter
drawing for *Incubation of the gosling*, 1793

the magnificent obstetrical atlases of the 18th century, such as those by William Hunter and Charles Nicholas Jenty. When human development was visually represented in relentless naturalistic detail for the first time, the depths of the mother's body were opened up for anatomists and artists to gaze upon. Given the powerful emotions with which the insides of women's bodies were invested, the progressive revelation of anatomical layers inevitably carried a frisson, a hint of the forbidden, a suggestion of voyeurism, perhaps of violation, and a consciousness of a newly visible land. Even when the life cycle was an animal's, the sense of novelty, of revelation, remained. Another form of series is thus the successive layers of which complex organic forms are composed, and which can be laid out in a sequence of images, usually starting with the intact body. Where such a series ended depended on the anatomical project in question: in the obstetric atlases, it was generally the inside of the womb, but in other depictions it was inner organs or bones. The visual evidence suggests that unveiling was a compelling metaphor for the progressive dismantling of a body, especially a female one, not least because the skin can easily be imagined as a type of veil. So, at least three different kinds of series were present in anatomical illustrations – developmental ones, where time was the variable; anatomical layers, where degrees of interiority were involved; and levels of complexity, where, as in Lavater's heads, a progressive movement towards an ideal, perfect or highly elaborate type was depicted.

Furthermore, such series were, sometimes overtly, and at others by implication, troubling. We can see this particularly clearly in a fourth kind of series, which was explicitly moral. This comes, I suggest, in two forms. The first can be illustrated by Hogarth's *Four Stages of Cruelty*, which shows the gradual degradation of a young man who, having tormented animals and killed his pregnant lover, is himself dissected by surgeons (cat. 89). This example of a 'modern moral subject' uses the idea of a life being exemplary, in this case negatively so, and the penetration of the body, showing and defiling its contents, are appropriate punishments for a character's misdemeanours. The second is a form of *memento mori*. The most obvious series that anatomists see, even if they rarely record it, is the progressive decay of flesh following death. This is, implicitly, a moral process, because death raises questions about an afterlife and about the quality of the life that has been lived. Just deserts.

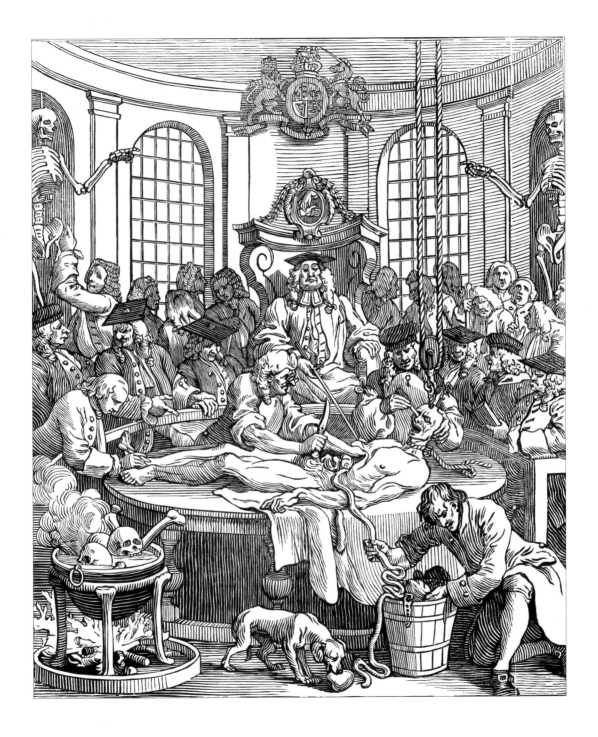

89
after William Hogarth
The Reward of Cruelty from *The Four Stages of Cruelty*, 1750/51

Even in a secular age, people reflect constantly, one might say obsessively, on the theme of mortality. They think about death, they reconceptualise it, struggle with it, and with its implications. For many centuries, when it came to pictures, the skeleton was the conventional motif through which such issues were raised. Hence figures that are half skeleton and half flesh, are also series – they evoke the passage from life to death, a particular form of time sequence, which is morally charged. And, to extend the point, highly realistic depictions, whether two- or three-dimensional (especially wax), which simulate life, by that very token, serve as reminders of death.

In stressing the point that art and anatomy involve self-conscious intellectual discipline, that they are subject to social, and specifically moral, constraints, and that they deploy pictorial conventions, I have emphasised one aspect of representations of the body in western societies since the Renaissance. There is another, wilder aspect, which I have only hinted at so far. Bodies are dangerous terrain, not only because they suffer, endure pain, die and decay, but also because they are the medium through which all experience is apprehended. Everything that is most unsettling about human experience can be directly associated with bodies. Perhaps we should put it the other way round: everything to do with the body is potentially unsettling. Erotic experience is a case in point. Any naked body raises the possibility of a sexual response, although it can be depicted in a way that, as far as possible and given the conventions of time, forecloses it. Many anatomical images register gender differences, associate them with sexuality (for example, 'Adam' and 'Eve' figures, cat. 154), emphasise the sexual organs, or place bodies in poses that carry erotic connotations – open legs, head thrown back, eyes rolled up, breasts revealed, body reclined (cats. 38 and 41). Viewers respond to far more than overtly gendered or sexualised images, to particular shapes or poses; even body fragments can arouse or trouble (the same word in French!). Yet neither artists and anatomists on the one hand, nor viewers on the other, are fully conscious of all these dimensions when making or responding to body images.

Certainly the development of scientific psychology over the 19th century and the dissemination of psychoanalytic ideas over the 20th century have brought huge changes in this respect, since

99
Charles Landseer
View of muscles of thorax of supine cadaver, 19th century

they have familiarised significant proportions of the population with assumptions about the importance of the unconscious and with some of its main tropes. Photography has been an integral part of these developments, and the keen interest of many artists, from the early 20th century onwards, in psychoanalytic theories has meant that art is now considerably more overt in the way it uses the body to make trouble, especially 'gender trouble' (*Butler*, 1990). Yet we should not imagine that in a pre-Freudian world these matters were absent from artistic or anatomical discourse. After all, the intellectual traditions on which artists and anatomists drew contained extensive discussions, not just of sexual experience and of reproduction, but of myths and symbols to do with gender and the erotic. Thus we might expect, what is indeed the case, that while they may strive for self-conscious discipline, many images of the human body are also, whether knowingly or not, free associating.

A particularly striking example of this is the elaborate plate to Hogarth's *Analysis of Beauty*, 1753 (cat. 88). Hogarth made deliberate use of series here – see numbers 1 to 9, 49 and 50 for instance, where a shape is gradually changed from being almost straight to being markedly curvaceous. The image is full of fragments, body parts and objects with which viewers can make a variety of associations. Take, for example, number 88 – a left leg, presumably a woman's, stepping forward, and clothed in a flowing robe, reminiscent of Freud's beloved Gradiva. It is potentially a highly erotic image, and so in their way are numbers 65 to 67, also a left leg, seen from the back, with muscle shapes delineated, and suggestive of masculine power. Taken as a whole, the plate is a complex assemblage of visual references, an array of suggestive elements, which viewers can use as they wish. It is ironic that Hogarth's text was didactic and highly normative, and that it did not receive a warm response. Despite his intentions, this carefully numbered plate, designed to expound key points in an idiosyncratic theory of beauty, escapes from its maker's grasp.

Contemporary forms of visual display tend to decontextualise works of art. Sometimes this is a deliberate policy, produced and sustained by a modernist aesthetic, at others it is a by-product of widely held views about what audiences want, expect and will tolerate. While there is widespread dissatisfaction with a precious elevating of art and valued objects, few

88
William Hogarth
plate 1 from *The Analysis of Beauty*, 1753

effective remedies have so far been developed. We often talk about the need for context, but what does 'context' mean? Is it more than 'background'? Museums and galleries turn most readily to artists' lives to supply context. Biographical questions can indeed be generative. Who were the makers of anatomical images? What was their social postition? How did diverse occupational groups work together? How did anatomy fit into an artistic or a medical life? Once such questions are posed, the social setting begins to come to life. We can imagine Edwin Landseer and his brothers taking anatomy lessons from a medical man as did many other artists. The Landseers were instructed by Charles Bell, the brother of John Bell, and a distinguished Scottish medical man with a profound interest in art and in the representation of the human body. Although he never succeeded in his ambition of becoming Professor of Anatomy at the Royal Academy, Charles Bell could be seen as following in the footsteps of his countryman William Hunter, who was the first to hold the post. Hunter collected art and was friendly with artists, engravers and collectors. Charles Bell taught a number of artists and was himself skilled in drawing, painting and engraving. The elaborate networks between artists and anatomists are a particularly striking aspect of 'context'. The collaboration between the artist Jan van Riemsdyck, who specialised in natural historical and medical work, and anatomists such as William Hunter and Jenty, for instance, is an excellent example of the complex relationships between artists, print-makers, collectors and medical men, that are particularly characteristic of the 18th century. And, in the lives of a number of important artists – Michelangelo, Leonardo and Dürer are obvious cases – their intense study of the human body can be traced in some biographical detail. Sometimes, further contextualising is possible by relating the resulting images to texts by the artist (for example, Dürer and Hogarth). An individual explanation is always easier to generate than a collective or social one – that is, we can more readily understand why a person, especially one associated with exceptional creative powers, would be drawn to examine and represent anatomical detail. The links between art and anatomy become particularly evident when such artists are committed to the study of nature, to theorising visual representation, and to verisimilitude. Both the ideas and the practices of these individuals, as revealed through biographical study, offer insights into the wider cultural setting.

I have argued that biography is an important and accessible element of context, but there are a number of aspects of context that biography alone will not reveal. The most vexed of these is the question of the audiences for anatomical images; biographical information may be useful but cannot fully explain the nature of actual or implied audiences. Many images were integral to artistic practice; they were exercises in exploration and self-discipline prior to producing a finished work (for example, Raphael, *Anatomical Study of the Swoooming Virgin Supported by two Holy Women*, 1507 (cat. 123)). In such cases, the audiences are the artist himself and perhaps patrons as well as collaborators and studio assistants. A significant proportion of anatomical images were illustrations in printed books. Sometimes these volumes were predominantly 'medical' or 'artistic', and at others the audience is less easily deduced from the work itself. Even the social groups implied by 'medical' and 'artistic' had notoriously blurred boundaries. There has been a tendency to see anatomically precise illustrations as serving a clear medical 'need', for example, as a substitute for satisfactory specimens. It is vital to be suspicious of such claims. Many illustrations have limited medical content, that is, they do not convey information otherwise unavailable. Until well into the 19th century medical education was diverse and relatively unstructured; there was no stable audience for didactic expositions or textbooks before then. Even where there was 'medical' content, its usefulness for medical practice could be limited or unclear. Often visual display itself seems to have been a powerful motive for publication, in which case the audiences would be those groups – and they are diverse in most periods – with an interest in such display: collectors and voyeurs as much as those with what could be regarded as a 'legitimate' medical interest. No commodity, and books are, after all, just that, can be controlled by its producer; anatomical books acquired an independent life, broke through their context of production, and were turned to a myriad of uses. That anatomy, precision about and understanding of bodily detail, was useful to both artists and anatomists is undeniable, but what such a general formula tends to marginalise is the mixtures of motives (conscious and unconscious) and of audiences around anatomical depictions.

Context is crucial in understanding the marriages and liaisons between art and anatomy, although just what counts as context and the best ways of analysing it remain open questions.

For each image there are innumerable contexts, since they are constantly being transplanted and transformed, re-viewed by each generation. The detailed study of such contexts is totally compatible with an appreciation of the visual pleasures that both stimulate the production of images of the body and make them of enduring fascination. Body images can indeed be taken out of context, viewed afresh, and reused for new purposes. Feminist artists have shown a particular concern with medical illustrations; they have visualised medical themes in fresh ways precisely because they feel that the theories and practices of medicine have exercised disproportionate power over women's bodies; they want to re-form the representation of the female body in order to affirm the value of women as subjects (including artistic ones). Selfhood seems to lie at the heart of much contemporary art practice that engages with the body. Indeed, as a culture, we seem to be obsessed with embodiment, with identity and with re-imagining pleasures and pains in an age of technological reproduction, robotics and artificial intelligence. These questions are not in themselves new. When William and John Hunter probed the placenta and tried to work out the precise connection between mother and child within that organ, they were, in a sense, inquiring into the nature of motherhood. But they did not present their studies in this form; it requires historical interpretation to show what was at stake in their anatomical work and how it was seen at the time. Hence, careful contextualising of the work of anatomists and of art-anatomy collaborations may be complementary both to an aesthetic response to their images and to an appreciation of how multi-faceted and emotionally charged depictions of the human figure take on lives of their own.

'Art and anatomy' covers a vast area of our cultural history; it was never an exclusively or predominantly medical domain. Rather it is a combination of tools and sources available for many different uses – erotic, aesthetic, emotional and so on. We can enjoy anatomical images as 'art', designed to give visual pleasure. We can use them to deepen contemporary understanding of an aspect of the past. We can treat them as providing elements for visual poems about the body, offering echoes, rhymes and fragments out of which new patterns are made. All this is possible because the body is central to our imaginary and, so far as we can tell, has always been so. Representations of the human body, then, constitute a

wonderfully rich set of resources, useful for moral and intellectual ends as well as artistic ones. It is vital to remember, however, that even the happiest of marriages have their volatile aspects and that the liaisons between art and anatomy are exciting precisely because they are also potentially dangerous.

Bibliographical Notes

The brief list below contains works directly relevant to this essay, and writings I have found especially useful in thinking about 'art and anatomy'.

Butler, Judith, 1990, *Gender Trouble: Feminism and the Subversion of Identity*, Routledge, New York

Coleman, William, 1971, *Biology in the Nineteenth Century: Problems of Form, Function and Transformation*, John Wiley, New York

Cooke, Lynne and Wollen, Peter, eds, 1995, *Visual Display: Culture Beyond Appearances*, Bay Press, Seattle

Douglas, Mary, 1966, *Purity and Danger: An Analysis of Concepts of Pollution and Taboo*, Routledge and Kegan Paul, London

Fox, Christopher, Porter, Roy and Wokler, Robert, eds, 1995, *Inventing Human Science: Eighteenth-Century Domains*, University of California Press, Berkeley

Gamwell, Lynn and Wells, Richard, eds, 1989, *Sigmund Freud and Art. His Personal Collection of Antiquities*, SUNY and the Freud Museum, New York and London

Haraway, Donna, 1989, *Primate Visions: Gender, Race and Nature in the World of Modern Science*, Routledge, New York

McManners, John, 1981, *Death and the Enlightenment*, Oxford University Press, Oxford

Nelson, Robert and Shiff, Richard, eds, 1996, *Critical Terms for Art History*, University of Chicago Press, Chicago

Rudwick, Martin, 1992, *Scenes from Deep Time: Early Pictorial Representation of the Prehistoric World*, University of Chicago Press, Chicago

Smith, Roger, 1997, *The Fontana History of the Human Sciences*, Fontana, London

154
Andreas Vesalius
from *De humani corpris fabrica librorum epitome*, 1543

Select Bibliography

Primary Sources
(mainly first editions have been listed)

Anatomy Textbooks
(* indicates anatomies specially compiled for the use of artists)

Albinus, Bernhard Siegfried, 1747, *Tabulae Sceleti et Musculorum Corporis Humani*, Leiden

Baillie, Matthew, 1799, *A series of engravings… to illustrate the Morbid Anatomy of… the Human Body*, London

Bell, Charles, 1798, *A System of Dissections, Explaining the Anatomy of the Human Body…*, Edinburgh

Bell, John, 1793, *The Anatomy of the Bones, Muscles, and Joints*, Edinburgh and London*

Berengarius (Giacomo or Jacopo Berengario da Carpi), 1521, *Commentaria… super anatomia Mundini*, Bologna
— 1522, *Isagogae breves…*, Bologna

Bidloo, Govard, 1685, *Anatomia humani corporis…*, Amsterdam (see Cowper, 1698)

Bouchardon Edme, 1741, *L'anatomie necessaire pour l'usage du dessein*, Paris*

Bourgery, Jean-Baptiste Marc, 1844, *Traité complete de l'anatomie de l'homme…*, Paris

Browne, John, 1681, *Myographia nova…*, London

Camper, Pieter (Petrus), 1760, *Demonstrationum anatomico-pathologicarum*, Amsterdam
— 1794, *The Works of the Late Professor Camper, On the Connexion Between the Science of Anatomy and the Arts of Drawing, Painting, Statuary, in Two Books*, trans. Cogan, T., London*

Casserius (Casserio, Giulio), 1627, *Tabulae anatomicae…*, Venice

Cattani, Antonio, 1780, *Osteografia e miografia della testa mani e piedi*, Bologna

Cesio, Carlo, 1679, *Cognitzione di muscoli del corpo humano per il disegno*, 2nd edition, Rome*

Cheselden, William, 1740, *The anatomy of the humane body*, 2nd edition, London
— 1733, *Osteographia (or the anatomy of the bones)*, London

Coiter, Volcher, 1572, *Externarum et internarum principalium humani corporis…*, Nuremberg

Columbus (Colombo, Realdo), 1559, *De Re Anatomica*, Venice

Cowper, William, 1698, *The anatomy of humane bodies…*, Oxford
— 1694, *Myotomia reformata…*, London

Gautier D'Agoty, Jacques Fabien, 1746, *Myologie complétte encouleur…*, Paris
— 1748, *Anatomie de la tête…*, Paris
— 1773, *Anatomie des parties de la génération de l'homme et de la femme…*, Paris

Douglas, James, 1707, *Myographiae…*, London

Dryander (Johannes Eichmann), 1536, *Anatomia capitis humani…*, Marburg

Estienne, Charles, 1545, *De dissectione partium corporis humani…*, Paris

Eustachius (Eustachio, Bartolomeo), 1714, *Tabulae anatomicae…*, G.M. Lancisi edition, Rome

Flaxman, John, 1833, *Anatomical Studies of the Bones and Muscles for the Use of Artists…*, London

Gamelin, Jacques, 1779, *Nouveau recueil d'ostéologie et de myologie, dessiné d'après nature par Jacques Gamelin de Carcassonne, Professor de Peinture, de l'Academie de Saint Luc de Rome, pour l'utilité des sciences et des arts…*, 2 vols, Toulouse*

Geminus, Thomas (after Vesalius), 1545, *Compendiosa totius anatomie delinatio…*, London (facsimile edition by C.D. O'Malley and C.D. Dawson, London, 1959)

Genga, Bernardino, 1691, *Anatomia per uso et intelligenza del disegno…*, Rome*

Gray, Henry, 1858, *Anatomy descriptive and surgical*, London

Hunter, William, 1774, *The anatomy of the human gravid uterus exhibited in figures*, Birmingham

Jenty, Nicholas Charles, 1757, *The demonstrations of a pregnant uterus…*, London

Kerckring, Theodor, 1670, *Spicilegium anatomicum…*, Amsterdam

Lavater John Caspar, 1775-78, *Physiognomische Fragmente…*, Leipzig and Winthertur
— 1789-98, *Essays on physiognomy designed to promote the knowledge and the love of mankind*, 3 vols, trans. by Holcroft, London
— 1824, *An Introduction to the Study of the Anatomy of the Human Body, particularly designed for the use of Painters, Sculptors and Artists in General*, London*

Lelli, Ercole, 1770, *Anatomia Esterna del Corpo Umano per uso de'Pittori*, Bologna*

Maclise, Joseph, 1851, *Surgical Anatomy*, London

Martinez, Crisostomo, 1689, *Nouvelles figures de proportions et d'anatomie du corps humain*, Paris

Mascagni, Paolo, 1816, *Anatomia per uso degli studiosi di scultura et pittura…*, Florence*

McMinn, R.M.H. and Hutchings, R.T., 1977, *Colour atlas of human anatomy*, London

Monnet, Charles, c. 1770, *Études d'anatomie à l'usage des peintres*, Paris*

Monro, Alexander, 1726, *The anatomy of the humane bones*, Edinburgh

Paauw, Pieter, 1615, *Primitae anatomicae. De humani corporis ossibus…*, Leiden

Petrioli, Gaetano, 1742, *Corso anatomico o sia universale commento nelle tavole del celebre Bartolomeo Eustachio*, Rome (see Eustachius, 1714)

Ploos van Amstel, Cornelis, 1783, *Aanleiding tot de kennis der anatomie, in de tekenkunst betreklykt ter menschbeeld…*, Amsterdam*

Quain, Richard, 1844, *The anatomy of the arteries of the human body…*, London

Ramsay, Alexander, 1813, *Anatomy of the heart, cranium and brain…*, Edinburgh and London

Ruini, Carlo, 1598, *Dell'anatomia… del cavallo*, Bologna

Ruysch, Frederick, 1701-28, *Thesaurus anatomicus*, 10 vols, Amsterdam
— 1721, *Opera omnia anatomico-medico, chirurgica*, Amsterdam

Ryff, W.H., 1541, *Anatomia omnium humani corporis partium descriptio…*, Strasburg

Salvage, Jean-Galbert, 1812, *Anatomie du gladiateur combattant, applicable aux beaux arts…*, Paris*

Scarpa, Antonio, 1794, *Tabulae neurologicae…*, Pavia

Sibson, Francis, 1869, *Medical Anatomy, or Illustrations of the relative positions and movements of the internal organs*, London

Smellie, William, 1754, *A sett of anatomical tables with explanations… of the practice of midwifery*, London

Soemmerring, Samuel Thomas von, 1797, *Tabula sceleti feminii…*, Frankfurt

Spigelius, Adrianus (Adriaan van den Spieghel), 1626, *De formato foetu…*, Venice
— 1627, *De humani corporis fabrica libri decem…*, Venice

Stubbs, George, 1766, *The anatomy of the horse, in 18 tables all done from nature*, London*
— 1804-17, *A comparative anatomical exposition…*, London

Sue, Jean-Joseph, 1788, *fils Elémens d'anatomie à l'usage des peintres, des sculpteurs et des amateurs*, Paris*

Tinney, John, 1743, *A Compendious Treatise of Anatomy, Adapted to the Arts of Designing, Painting and Sculpture*, London*

Tortebat, Francoise and de Piles, Roger, 1668, *Abrégé d'anatomie accomodé aux arts de peinture et de sculpture*, Paris*

Hamusco, Juan de Valverde de (or Amusco), 1589, *La anatomia del corpo humano…*, Rome

Van der Gracht, Jacob, 1634, *Anatomie der witterlicke deelen van het menschelik Lichaem… voor Schilders, Beelt-houwers, Plaet-snyders als oock Chirgiens*, The Hague*

Vesalius, Andreas, 1538, *Tabulae anatomicae sex*, Venice
— 1543, *De humani corporis fabrica…*, (the Fabrica), Basle
— 1543, *De humani corporis fabrica librorum epitome*, (the Epitome), Basle

Vesling, Johannes, 1641 and 1647, *Syntagma anatomicum…*, Padua

Walton, Elijah, 1865, *The Camel: Its Anatomy, Proportions and Paces*, London*

Artists' Manuals

Audran, Gerard, 1683, *Les proportions du corps humain, mesurées sur les plus belles figures de l'antiquité*, Paris

Bartolozzi, G., 1790, *Cipriani's Rudiments of Drawing engraved by G. Bartolozzi*, London

Beham, Hans Sebald, 1546, *Das Kunst und Lehrbuchlein…*, Frankfurt

Bell, Charles, 1806, *Essays on the Anatomy of Expression in Painting*, London

Blanc, Charles, 1867, *Grammaire des arts du dessin*, Paris

Bloemart, Abraham, c. 1650, *Artes Apellae…*, Amsterdam

Browne, Alexander, 1669, *Ars pictoria, or an Academy treatment of Drawing, Painting, Limning, Etching, etc.*, London

Carracci, Agostino (after Luca Ciamberlano), 1644, *Scuola perfetta per imparare a Disegnare tutto il corpo Humano*, Padua

Cousin, Jean, 1560, *Livre de Perspective*, Paris
— 1595, *Livre de pourtraiture*, Paris

De Lairesse, Gérard, 1701, *Grondlegginge ter teekenkonst*, Amsterdam

Della Porta, G., 1586, *De Humana Physionomia*, Naples

De Piles, Roger, 1684, *Les premiers élémens de la peinture pratique*, Paris

Diderot, Denis and d'Alembert, Jean de Rond, 1751-72, *Encyclopédie…*, 17 vols, Paris

Dürer, Albrecht, 1528, *Vier Bücher von menschlicher Proportion*, Nuremberg

Fialetti, Odoardo, 1608, *Il vero modo et ordine per dissegnar tutte le parti et membra del corpo humano*, Venice

Franco, Giacomo (Palma Giovane), 1611, *De excellentia et nobilitate delineationis…*, Venice

Girodet-Trioson, Anne-Louis, 1826, *Cahier de Principes…*, Paris

Guercino (Barbieri, Francesco), 1619, *Jo. Franciscus Barberius Centen Inventor Mantua*, Italy

Hidalgo, J.G., 1693, *Principios para estudiar el nobilissimo y real arte de la pintura*, Madrid

Hogarth, William, 1753, *The Analysis of Beauty*, London (facsimile edition, The Scolar Press, London, 1969)

Jamnitzer, Wenzel, 1568, *Perspectiva corporum regularium*, Nuremberg

Lautensack, Heinrich, 1564, *Des circkels und Richtscheyts auch der Perspective, und Proportion der Menschen und Rosse*, Frankfurt

Leclerc, S., 1696, *Les Caractères des passions gravées sur les dessins de M. Le Brun*, Paris

Leonardo da Vinci, 1890, *Trattato della Pittura*, Rome

Lomazzo, Giovanni Paolo, 1584, *Trattato dell'arte della pittura*, Milan

Pacioli, Luca, 1509, *De Divina proportione*, Florence

Rubens, Peter Paul, 1773, *Theorie de la figure humaine*, Jombert, ed., Paris

Rubens, Peter Paul, undated, *Petrus Paulus Rubbens Delineavit*, Pontius, ed., Antwerp

Sue, Jean-Joseph, 1797, *fils Essai sur la physiognomie des corps vivans*, Paris

Sulzer, Johann George, 1777, *Allgemeine Theorie des schönen Künste…*, 2 vols, Biel

Van de Passe, Crispijn, 1643, *Van't Light der Teken en Schilderkonst…*, Amsterdam

Cultural, historical and theoretical bibliography

Alberti, Leon Battista, 1991, *On Painting*, trans. Grayson, C., London

Ameisenowa, Z., 1963, *The Problem of the Three Anatomical Models in the Jagiellonian Library*, Varsovie-Cracovie

Amerson, L. Price, 1976, 'Catalogue du moulage d'Écorché conserves à la Royal Academy of Arts de Londres', *L'Écorché*, cahier no. 3, Ecole Regionale des Beaux Arts, Rouen, November

Armaroli, Maurizio et al, 1981, *Le Cere Anatomiche Bolognesi del Settecento*, Conference Accademia delle Scienze, September -November 1981, Università degli studi di Bologna

Arnason, H.H., 1975, *The Sculptures of Houdon*, Phaidon Press, London

Arnold, Ken and Kemp, Martin, 1995, *Materia Medica: A New Cabinet of Medicine and Art*, exhibition catalogue, Wellcome Institute for the History of Medicine, London

Azibert, C., 1947, *Jacques Gamelin 1738-1803 son oeuvre anatomique*, Carcassonne

Barzman K.-E., 1989, 'The Florentine Accademia del Disegno: Liberal Education and the Renaissance Artist' in Boschloo et al, eds., *Academies of Art between Renaissance and Romanticism*, op. cit., pp. 14-32

Barzun, J., 1974, *Burke and Hare: The resurrection men*, The Scarecrow Press, Metuchen, New Jersey

Bignamini, Ilaria and Postle, Martin, 1991, *The Artist's Model: Its Role in British Art from Lely to Etty*, exhibition catalogue, University Art Gallery Nottingham and The Iveagh Bequest, Kenwood

Bolten, Jaap, 1985, *Dutch and Flemish Drawing Books 1600-1750, Method and Practice*, Edition PVA, Pfalz

Boschloo, W.A. Anton et al, 1989, *Academies of Art between Renaissance and Romanticism*, SDU, S-Gravenhage

Brehm, Margrit, 1996, 'The Body and its Surrogates' in *Cindy Sherman*, exhibition catalogue, Museum Boijmans von Beuningen, Rotterdam

Bromová, V., 1997, *On the Edge of the Horizon*, exhibition catalogue, Metropolitan Galleries of Prague, Prague

Bucci, Marco, 1969, *Anatomia come Arte*, Florence

Bury, Michael, 1990, *Giulio Sanuto: A Venetian Engraver of the Sixteenth Century*, exhibition catalogue, National Gallery of Scotland, 1 November-16 December, Edinburgh

Bynum, C.W., 1991, *Fragmentation and Redemption: Essays on Gender and the Human Body in Medieval Religion*, Zone Books, New York

Bynum, W.F. and Porter, R.S., eds, 1985, *William Hunter and the Eighteenth Century Medical World*, Cambridge University Press, Cambridge

— 1993, *Medicine and the Five Senses*, Cambridge University Press, Cambridge

Callen, Anthea, 1995, *The Spectacular Body: Science, Method and Meaning in the Work of Degas*, Yale University Press, New Haven and London

— 1997, 'The Body and Difference: Anatomy training at the Ecole des Beaux-Arts in Paris in the later nineteenth century', *Art History*, vol. 20, no. 1, pp. 23-60, March

Carlino, Andrea, 1995, *Corpi di carta. Fogli Volanti e Diffusione delle conoscenze anatomiche nell' Europa Moderna*, Leo S. Olschki Editore, Florence

— 1995, 'Know Thyself Graphic Communication and Anatomical Knowledge in Early Modern Europe' in *RES Anthropology and Aesthetics*, XXVII, Santa Monica, CA and Cambridge, Mass.

— forthcoming, *Paper Bodies: Anatomical Fugitive sheets in the Age of Printing and Dissecting*, Medical History supplement, Wellcome Institute for the History of Medicine, London

Cazort, Mimi, Kornell, Monique and Roberts, K.B., 1996, *The Ingenious Machine of Nature: Four Centuries of Art and Anatomy*, exhibition catalogue, National Gallery of Canada, Ottawa

Choulant, Ludwig, 1920, *History and Bibliography of Anatomic Illustration*, trans. and ed. by Mortimer, Frank, University of Chicago Press, Chicago

Claire, Jean, ed., 1993, *L'âme au corps: arts et sciences 1793-1993*, exhibition catalogue, Galeries nationales du Grand Palais, 1993-1994, Réunion des musées nationaux, Gallimard/Electa, Paris

Clark, Kenneth, 1968, *The Drawings of Leonardo da Vinci in the collection of Her Majesty the Queen...*, 3 vols, Phaidon Press, London

Clayton, Martin, 1997, *Leonardo da Vinci: One Hundred Drawings from the Collection of Her Majesty the Queen*, exhibition catalogue, The Queen's Gallery, Buckingham Palace, London

Condivi, A., 1553, *The Life of Michelangelo*, Wohl, H., ed., Baton Rouge, Louisiana (facsimile edition 1976)

Cope, Z., 1953, *William Cheselden 1688-1752*, E. & S. Livingstone, Edinburgh

Crary, Jonathan et al, eds, 1989 and 1990, *Fragments for a History of the Human Body*, Parts I, II, III, Zone Books, New York

Darlington, Anne Carol, 1990, *The Royal Academy of Arts and its Anatomical Teachings; with an examination of the art-anatomy practices during the eighteenth and early nineteenth centuries in Britain*, unpublished PhD thesis, University of London

Doherty, Terence, 1974, *The Anatomical Works of George Stubbs*, Secker & Warburg, London

Edgerton, Jr, S.Y., 1985, *Pictures and Punishment*, Ithaca, New York and London

Elkins, James, 1986, 'Two Conceptions of the Human Form: Bernard Siegfried Albinus and Andreas Vesalius', *Artibus et Historiae*, 14, pp. 91-106

— 1984, 'Michelangelo and the Human Form: His Knowledge and Use of Anatomy', *Art History*, 7, no. 2, pp. 176-86

Ernst, Max, 1929, *La femme 100 têtes*, Éditions du Carrefour, Paris

— 1930, *Rêve d'une petite fille qui voulut entrer au carmel*, Paris
— 1934, *Une semaine de bonté...*, Éditions Jeanne Bucher, Paris

Ferrari, Giovanna, 1987, 'Public Anatomy Lessons and the Carnival: The Anatomy Theatre of Bologna' in *Past and Present*, no. 117, November, pp. 50-106

1977, 'La Ceroplastica nella Scienza and nell'Arte', Atti del I Congresso Internazionale, Florence, 3-7 June 1975 (Biblioteca della Rivista di Storia delle Scienze Mediche and Naturali Vol. XX), Leo S. Olschki Editore, Florence

Freud, Sigmund, 1985, 'The Uncanny' (*Das Unheimliche*) in *Art and Literature*, Dickson, Albert, ed., The Penguin Freud Library, London, vol.14

Frey, K., ed., 1923-30, *Der Literarische Nachlass G. Vasari*, 2 vols, Munich, I

Gent, Lucy and Llewellyn, Nigel, eds, 1990, *Renaissance Bodies: The Human Figure in English Culture c. 1540-1660*, Reaktion Books, London

Gilman, Sander L., 1982, *Seeing the Insane: A Cultural History of Madness and Art in the Western World*, John Wiley & Brunner/Mazel, New York

— 1995, *Picturing Health & Illness: Images of Identity and Difference*, John Hopkins University Press, Baltimore

Grosz, Elizabeth, 1994, *Volatile Bodies: Toward a Corporeal Feminism*, Indiana University Press, Bloomington and Indianapolis

Haraway, Donna J., 1991, *Simians, Cyborgs, and Women: The Reinvention of Nature*, Free Association Books, London

Hecksher W., 1958, *Rembrandt's Anatomy Lesson of Dr. Nicolas Tulp: An Iconological Study*, New York University Press, New York

Héritier-Augé Francoise, 1990, 'Semen and Blood: Some Ancient Theories Concerning Their Genesis and Relationship' in Feher, M., ed., *Fragments for a History of the Human Body: Part Three*, Zone Books, New York, pp. 159-175

Huard, P. and Grmek, M.D., 1965, *L'Oeuvre de Charles Estienne et l'école anatomique*, Au cercle du livre précieux, Paris

Huisman, Tim, 1992, 'Squares and Diopters: The Drawing System of a Famous Anatomical Atlas', *TRACTRIX* (Publication of the Dutch Society for the History of Medicine and Science), 4, pp. 1-11

Impey, Oliver and MacGregor, Arthur, eds, 1985, *The Origins of Museums: The Cabinet of Curiosities in Sixteenth- and Seventeenth-Century Europe*, Clarendon Press, Oxford

Johnson, Mark, 1987, *The Body in the Mind: The Bodily Basis of Meaning, Imagination and Reason*, University of Chicago Press, Chicago

Jordanova, L.J., 1985, 'Gender, generation and science: William Hunter's obstetrical atlas' in Bynum, W.F. and Porter, R.S., eds, *William Hunter and the Eighteenth-Century Medical World*, Cambridge University Press, Cambridge, pp. 385-412

— 1989, *Sexual Visions: Images of Gender in Science and Medicine between the Eighteenth and Twentieth Centuries*, Harvester/Wheatsheaf, Hemel Hempstead and University of Wisconsin Press, Madison, Wisconsin

— 1993, 'The art and science of seeing in medicine: Physiognomy 1780-1820' in Bynum, W.F. and Porter, R.S., eds, *Medicine and the Five Senses*, Cambridge University Press, Cambridge, pp. 122-133

— 1995, 'The Representation of the Human Body: Art and Medicine in the Work of Charles Bell' in Ballen, B., ed., *Towards a Modern Art World*, Yale University Press, pp. 79-94

— 1996, 'Medicine and Genres of Display' in Cooke, L. and Wollen, P., eds, *Visual Display: Culture Beyond Appearances*, Bay Press, Seattle, pp. 202-217

Keele, Kenneth D. and Pedretti, Carlo, 1979, *Leonardo da Vinci. Corpus of the Anatomical Studies in the collection of Her Majesty the Queen at Windsor Castle*, 2 vols, Johnson Reprint Co. Ltd, Harcourt Brace Jovanovich

Keele, Kenneth D. and Roberts, Jane, 1977, *Leonardo da Vinci: Anatomical Drawings from the Royal Collection*, exhibition catalogue, Royal Academy of Arts, London

Kemp, Martin, 1970, 'A Drawing for the Fabrica and Some Thoughts upon the Vesalius Muscle-Men', *Medical History*, XIV:27, pp. 277-88

— 1975, *Dr. William Hunter at the Royal Academy of Arts*, Glasgow
— 1976, 'Dr. William Hunter on the Windsor Leonardos and his Volume of Drawings attributed to Pietro da Cortona', *Burlington Magazine*, CXVIII, no. 876, pp. 144-48

— 1990, *The Science of Art: Optical Themes in Western Art from Brunelleschi to Seurat*, Yale University Press, New Haven and London

— 1993, '"The mark of truth": looking and learning in some anatomical illustrations from the Renaissance and eighteenth century' in W.F. Bynum and Porter, R.S., eds, *Medicine and the five senses*, Cambridge University Press, Cambridge, pp. 85-121

Knox R., 1852, *Great Artists and Great Anatomists*, H. Renshaw, London

Kornell, Monique, 1989, 'Rosso Fiorentino and the anatomical text', *The Burlington Magazine*, LXXXI, December

— 1989, 'Anatomical Drawings by Battista Franco', *Bulletin of the Cleveland Museum of Art*, vol. 76, no. 9
— 1993, *Artists and the Study of Anatomy in Sixteenth-Century Italy*, unpublished PhD dissertation, Warburg Institute, University of London

— 1998, 'Drawings for Bartolomeo Passarotti's Book on Anatomy' in *Drawing 1400-1600: Invention and Innovation*, Currie, S., ed., Ashgate, London

Kristeva, Julia, 1982, *Powers of Horror: An Essay on Abjection*, trans. Roudiez, Leon S., Columbia University Press, New York and Chichester

Lanza, Bendetto et al, 1997, *Le Cere Anatomiche della Specola*, Editore Arnaud, Florence, 2nd edition

Laqueur, Thomas W., 1986, 'Orgasm, Generation, and the Politics of Reproductive Biology', *Representations*, 4, Spring

— 1989, 'Amor Veneris, vel Dulcedo Appeletur' in Feher, M., Naddaff, R. and Tazi, N., eds, *Fragments for a History of the Human Body Part III*, Zone Books, MIT Press, Cambridge, Mass. and London, pp. 90-131

— 1996, *Bodies, Pleasures, Sexual Difference*, Harvard University Press, Cambridge, Mass.

Lautréamont, Comte de (Ducasse, Isidor), 1868, *Chants de Maldoror*, Paris

Lemire, Michel, 1990, *Artistes et Mortels*, Editions Raymond Chabaud, Paris

Lipking, Lawrence, 1970, *The Ordering of the Arts in Eighteenth-Century England*, Princeton Univerity Press, Princeton

Maddison, Francis and Savage-Smith, Emilie, 1997, *Science, Tools and Magic: The Masser D. Khalili Collection of Islamic Art*, Oxford

Martensen, Robert, 1994, 'The Transformation of Eve' in Porter, Roy and Teich, Mikulas, eds, *Sexual Knowledge, Sexual Science: The History of Attitudes to Sexuality*, Cambridge University Press, Cambridge

Mayor, A. Hyatt, 1984, *Artists & Anatomists*, The Artist's Limited Edition in association with the Metropolitan Museum of Art

Mulvey, Laura, 1975, 'Visual Pleasure and Narrative Cinema', *Screen*, 16, no. 3, pp. 8-18

— 1996, *Fetishism and Curiosity*, Indiana University Press, Bloomington and BFI, London

Newman, Karen, 1996, *Fetal Positions: Individualism, Science, Visuality*, Stanford University Press, Stanford, California

Nilsson, Lennart, 1965, *A Child is Born*, Dell, New York

O'Connell, Sheila, 1984, 'An Explanation of Hogarth's Analysis of Beauty, Plate I, Fig. 66', *Burlington Magazine*, Shorter Notices, vol. CXXVI, no. 970, January

O'Malley, C.D., ed., 1959, *Thomas Geminus Compendiosa totius anatomie delineatio*, Facsimile Dawson, London

— 1964, *Andreas Vesalius of Brussels 1514-1564*, University of California Press, Berkeley

Pedretti, Carlo, 1977, *The Literary Works of Leonardo da Vinci, Compiled and Edited from the Original Manuscripts by Jean Paul Richter*, 2 vols, Berkeley and Los Angeles

Petherbridge, Deanna, 1991, *The Primacy of Drawing: An Artist's View*, exhibition catalogue, National Touring Exhibitions from the South Bank Centre, London

Popham, A.E., 1946, *The Drawings of Leonardo da Vinci*, Cape, London

Porter, Roy and Teich, Mikulas, 1994, *Sexual Knowledge, Sexual Science: The History of Attitudes to Sexuality*, Cambridge University Press, Cambridge

Punt, H., 1983, *Bernard Siegfried Albinus 1697-1770, On human nature: anatomical and physiological ideas in eighteenth-century Leiden*, B.M. Israel, Amsterdam

Purcell, R.W. and Gould, S.J., 1993, *Finders Keepers: Eight Collectors*, Pimlico, London (first published by Hutchinson Radius, 1992)

Richardson, Ruth, 1987, *Death, Dissection and the Destitute*, London

Roberts, K.B. and Tomlinson, J.D.W., 1992, *The Fabric of the Body: European Traditions of Anatomical Illustration*, Clarendon Press, Oxford

Rodari, Florian, 1996, *Anatomie de la Couleur: L'invention de l'estampe en couleurs*, exhibition catalogue, Bibliothèque nationale de France, Paris and Musée Olympique Lausanne, Lausanne

Rupp, Jan C.C., 1990, 'Matters of Life and Death: The Social & Cultural Conditions of the Rise of Anatomical Theatres, with special reference to seventeenth century Holland', *History of Science*, XXVIII, pp. 263-287

Saunders, J.B. and O'Malley, C.D., 1950, *The Illustrations from the Works of Andreas Vesalius of Brussels*, World Publishing, Cleveland

Savage-Smith, Emilie, 1998, *Tashrih* in *The Encyclopaedia of Islam*, vol. 9, 2nd edition, Brill, Leiden

— 1994, *Islamic Culture and the Medical Arts*, National Library of Medicine, Bethesda, Maryland

Sawday, Jonathan, 1995, *The Body Emblazoned: Dissection and the Human Body in Renaissance Culture*, Routledge, London and New York

Schiebinger, Londa, 1987, 'Skeletons in the Closet: The First Illustrations of the Female Skeleton in Eighteenth Century Anatomy' in Gallagher, C. and Laqueur, T., eds, *The Making of the Modern Body: Sexuality and Society in the Nineteenth Century*, University of California Press, Berkeley, Los Angeles and London

— 1993, *Nature's Body: Sexual Politics and the Making of Modern Science*, Pandora/HarperCollins, London

Schouten, Frans et al, 1989, *Grotesque: Natural Historical & Formaldehyde Photography*, exhibition catalogue, Fragment Uitgeverij, Amsterdam

Schupbach, William, 1982, *The Paradox of Rembrandt's Anatomy of Dr. Tulp'*, Wellcome Institute for the History of Medicine, London

Spies, Werner, 1991, *Max Ernst. Collages. The Invention of the Surrealist Universe*, trans. Gabriel, J.W., Harry N. Abrams, New York

Stafford, Barbara Maria, 1991, *Body Criticism: Imaging the Unseen in Enlightenment Art and Medicine*, MIT Press, Cambridge, Mass. and London

Surtees, Virginia, ed., 1981, *The Diary of Ford Madox Brown*, New Haven and London

Thornton, John L., 1982, *Jan van Rymsdyk: Medical Artist of the Eighteenth Century*, Oleander Press, Cambridge and New York

Vasari, Giorgio, 1987, trans. George Bull, *Lives of the Artists*, 3 vols, Penguin Books, Harmondsworth

Winckelmann, J.J., 1972, *Winckelmann: Writings on Art*, Irwin, David, ed., Phaidon Press, London

Wyss, Edith, 1996, *The Myth of Apollo and Marsyas in the Art of the Italian Renaissance: An Inquiry into the Meaning of Images*, University of Delaware Press, Newar and Associated University Presses, London

List of Works

Note: measurements are in centimetres, height × width unless stated otherwise; page numbers after catalogue numbers indicate works which are illustrated.

1
Anon (Padua or Verona)
An 'antique' figure seen from the back, 15th century
pen and brown ink, heightened with white body colour on faded *carta azzura*; 27.8 × 11.5
Chatsworth 888B (Jaffe 937)
Lent by the Duke of Devonshire and the Chatsworth Settlement Trustees

2 (p. 42)
Anon
Tashrih-i Mansuri: The Anatomy of Mansur of Shiraz, 15th century
bound manuscript, with illustrations in ink and watercolour, 27 folios; 22.7 × 17.4
MSS 387
The Nasser D. Khalili Collection of Islamic Art
Photo © Nour Foundation

3
Anon
Tabula exhibens insigniora maris viscera..., 1573
flap anatomy, S. Gronenberg, Wittenberg
coloured woodcut; 38 × 31
EPB 297 (16)
Wellcome Institute for the History of Medicine Library, London

4
Anon
Tabula foeminae membra demonstrans..., 1573
flap anatomy, S. Gronenberg, Wittenberg
coloured woodcut; 38 × 31
EPB 298
Wellcome Institute for the History of Medicine Library, London

5
Anon
Anatomical illustration showing the veinous system (recto), late 16th century, Iran
ink and opaque watercolour on burnished laid paper; 20.3 × 15.4
MSS 454.2
The Nasser D. Khalili Collection of Islamic Art

6
Anon
Écorché figurine, 17th century, Italy
bronze; 14.1 (height)
Inv. No. M51. 1952 Alfred Spero Collection
The Syndics of the Fitzwilliam Museum, Cambridge

7
Anon
Anatomical female figure..., possibly 17th century, Germany
ivory, wood, cloth, leather; 5.3 × 9.2 × 22
A3186
Science Museum, London

8
Anon
Anatomical male figure..., possibly 17th/18th century, Germany
ivory, wood, paper, velvet; 4.5 × 7.3 × 23
A642639
Science Museum, London

9 (p. 71)
Anon
Drawing of dissected foot showing tendons, late 18th century
possibly related to plates from A. Cattani, *Osteografia e miografia*, Bologna, 1780
black and white chalk on paper; 18.4 × 18.6
8506
Wellcome Institute for the History of Medicine Library, London

10 (p. 57)
Anon
Pregnant female figure, 18th/19th century
ivory, metal; 16 × 39
A641036
Science Museum, London
Photo: Science & Society Picture Library

11 (p. 42)
Anon
Tashrih-i Mansuri: The Anatomy of Mansur of Shiraz, 18th/19th century, Punjab Hills
manuscript; 30.5 × 18
Or. MS 416, Folio 63
Edinburgh University Library

12 (p. 53)
Anon
An anatomical painting, 19th century, Iran
oil on canvas; 201 × 122
MSS 873
The Nasser D. Khalili Collection of Islamic Art
Photo © Nour Foundation

13
Anon
Polychrome écorché figure, 19th century
plaster; 100 (height)
Department of Anatomy, University of Edinburgh

14
Anon
Anatomical model of head, showing section of brain, possibly 19th century, Germany
wax, wood; 22 × 25 × 20.5 (depth)
1988-258
Science Museum, London

15
Anon
The Edinburgh Stereoscopic Atlas of Obstretrics, Vol II, 1908
eds Barbour Simpson and Edward Burnet
albumen paper prints
plates: 18.9 × 20.2; box: 5 × 19 × 24
Michael and Jane Wilson Collection

16 (p. 83)
Max Aguilera-Hellweg (b. 1955)
Untitled, (Spiegel-Wycis Stereoencephalotome, Model 2, with wax model demonstrating the lymph glands of the neck), 1995
gelatin silver print; 61 × 50.8
The artist
© Max Aguilera-Hellweg 1997

17 (p. 12)
Pietro Francesco Alberti (1584-1638)
Academia di Pittori, c. 1600
etching; 41 × 52.8
B. xvii 313/1
The British Museum

18
Alessandro di Cristofano di Lorenzo Allori (1535-1607)
Studies of the left foot, c. 1560
black chalk on paper; 24.2 × 20.7
RL 0216 (P&W 1096)
Royal Library, Windsor Castle, lent by Her Majesty the Queen
Leeds and London only

19 (p. 9)
Alessandro di Cristofano di Lorenzo Allori
A man's left leg, progressively anatomised, mid-1560s
black chalk on paper; 42.2 × 30.8
Chatsworth 890
Lent by the Duke of Devonshire and the Chatsworth Settlement Trustees
Photo: Courtauld Institute of Art

20
Alessandro di Cristofano di Lorenzo Allori
Studies of hands showing stages of dissection (Etude de mains), 16th/17th century
black chalk on paper; 17.5 × 27.8
Inv. no. 12
Cabinet des dessins, Musées Nationaux du Palais du Louvre, Paris
London only

21 (p. 103)
Saint Aubin (1736-1807) for John Hunter
2 drawings for *Incubation of the gosling*, 1793
pen and ink and wash
158a: 27 × 19.5; 158b: 23 × 19.2
The Royal College of Surgeons of England

22
Gerard Audran (1640-1703)
Les proportions du corps humain, mesurées sur les plus belles figures de l'antiquité, 1683
Chez Gerard Audran, Paris
book; 41.5 × 29.5
Royal Academy of Arts, London

23
Louis Thomas Jérôme Auzoux (1797-1880)
Écorché Hand, 19th century
papier mâché; 55 (height)
Musée de l'Écorché d'Anatomie du Neubourg

24
Louis Thomas Jérôme Auzoux
Exploded head (demi-tête), 19th century
papier mâché; 51 × 53
Musée de l'Écorché d'Anatomie du Neubourg

25
Beth B (b. 1955)
Trophies #8 (Corseted and Normal Rib Cages), 1995
wax, resin, wood, glass and steel
129.5 × 66 × 108
Loaned by artist
Courtesy Laurent Delaye Gallery

26
Baccio Bandinelli (1488-1560)
Bacchus and a seated Panther, 16th century
pen and ink with slight wash; 43.6 × 27.2
Inv. Dyce 158
The Board of Trustees of the Victoria & Albert Museum

27
attrib. to Baccio Bandinelli (1488-1560)
Anatomical Drawings bound as Ontleed Kundige Tekeningen door Baccio Bandinelli, c. 1510-60
bound volume; 33 × 25
1866/12/8-640/669
The British Museum
London only

28
Domenico del Barbiere (called Domenico Fiorentino) (1501/06/ c. 1565)
Group of figures from Michelangelo's Last Judgement, c. 1545
etching; 36.4 × 22
Inv. no. V 2/71 (Zerner 3)
The British Museum

29
Herbert Bayer (1900-1985)
Self-Portrait, 1932
silver gelatin print; 35.3 × 28
Jonathan Bayer

30
Domenico Beccafumi (c. 1486-1551)
Studies of an arm, c. 1540-50
red chalk; 15 × 21
RL 0290 (AEP 134)
Royal Library, Windsor Castle, lent by Her Majesty the Queen
Leeds and London only

31 (pp. 17, 40)
John Bell (1763-1820)
Engravings Explaining the Anatomy of the Bones, Muscles and Joints, 1794
John Paterson, Edinburgh
book; 27 × 21
Royal Academy of Arts, London
Photo © Royal Academy of Arts Library

32
William Bell (d. 1792) for John Hunter (1728-1793)
3 drawings for *Incubation of the chick*, c. 1782
151a: 23.3 × 20.2; 152a: 18.2 × 12.5; 152b: 23.5 × 20.2
The Royal College of Surgeons of England

33 (p. 103)
William Bell for John Hunter
5 drawings for *Incubation of the chick*, c. 1782
152a: 15.4 × 13.7; 153b: 13.5 × 12.6; 153c: 12.6 × 8; 153d: 13.2 × 13; 153e: 17.1 × 12.5
The Royal College of Surgeons of England

34 (p. 52)
Berengarius (Berengario da Carpi) (c. 1460-1530)
Isagogae breves, 1522
book; 21 × 16.5
Special Collections Department, Glasgow University Library

35
Bianchi (19th century)
Art Students and Model, c. 1890
gelatin silver print; 17.7 × 23.7
Michael and Jane Wilson Collection

36
Luigi Schiavonetti (1765-1810)
after William Blake (1757-1827)
Blair's Grave, 1808
title page to *The Grave*
proof etching before lettering (no colour)
35.24 × 27.31
p. 505/1985
The Syndics of the Fitzwilliam Museum, Cambridge

37 (p. 16)
Ford Madox Brown (1821-1893)
Study of a Corpse for The Prisoner of Chillon, 1856
pencil; 16.5 × 28
(352/27)
Birmingham Museums and Art Gallery
Warwick and Leeds only

38 (pp. 32, 56)
John (Joannis) Browne (1642-1702)
Myographia Nova or a Graphical Description of all the Muscles in the Humane Body, as they arise in Dissection, 1698
printed by Thomas Milbourn for the author, London, 1698
book; 36.5 × 24.5
The Royal College of Surgeons of England

39 (p. 19)
Pieter Camper (1722-1789)
The works of the late Professor Camper on the Connexion between the Science of Anatomy and the Arts of Drawing, Painting. Statuary, 1794
trans. from Dutch by T. Cogan, published by C. Dilly, London
book; 29.6 × 24
Royal Academy of Arts, London
Photo © Royal Academy of Arts Library

40
Bernardino Capitelli (1590-1639) (previously attrib. to Polidoro (Caldara) da Caravaggio)
An Anatomical Dissection, 16th century
pen and brown ink; 17.1 × 25.1
Parker 480 (M.App. 2, p.273)
The Visitors of the Ashmolean Museum, Oxford

41 (p. 56)
Gian Jacopo Caraglio (c. 1500-1570)
after Perino del Vaga (1500-1546/47)
'Mercury' from Loves of the Gods, c. 1530
engraving; 17.3 × 13.4
B.12 1866/6-23-10
The British Museum

42
Agostino Carracci (1557-1602)
Studies of Feet and an Annunciation, c. 1592-94
pen and brown ink; 25.8 × 16.2
RL 2129r (Wittkower 134)
Royal Library, Windsor Castle, lent by Her Majesty the Queen
Leeds and London only

43 (p. 71)
Antonio Cattani (active 1770s-1780s)
Musculature of the Foot from Osteografia e miografia,
1790
engraving with etching; 21.5 × 33.8
29345.7 (Box 188)
The Board of Trustees of the Victoria & Albert
Museum
Photo: V & A Picture Library

44
Antonio Cattani
Musculature of the Hand from Osteografia e miografia,
1790
engraving with etching; 36.1 × 24
29345.9 (Box 188)
The Board of Trustees of the Victoria & Albert
Museum

45 (p. 92)
Antonio Cattani after Ercole Lelli (1702-1766)
Dorsal view of standing muscleman (as caryatid),
1781
published by Cattani e Nerozzi, Bologna
etching; 188 × 55.5
ICV 18759
Wellcome Institute for the History of Medicine
Library, London

46 (p. 92)
Antonio Cattani after Ercole Lelli
Frontal view of standing muscleman (as caryatid),
1781
published by Cattani e Nerozzi, Bologna
etching; 188 × 55.5
ICV 18796
Wellcome Institute for the History of Medicine
Library, London

47
Giuseppe Cesari (1568-1640)
Study from a model of an Écorché, c. 1600
based on Cigoli's écorché statuette
red chalk; 26.6 × 14
RL 0172 (AEP 221)
Royal Library, Windsor Castle, lent by Her
Majesty the Queen
Leeds and London only

48
Giuseppe Cesari (1568-1640)
Study from a model of an Écorché, seen from behind,
c. 1600
based on Cigoli's écorché statuette
red chalk; 22.6 × 13.9
RL 0173 (AEP 222)
Royal Library, Windsor Castle, lent by Her
Majesty the Queen
Leeds and London only

49
Helen Chadwick (1953-1996)
The Wigwam Age 5, from Ego Geometria Sum,
1982-1984
photographic emulsion on plywood
89 × 79 × 79
Helen Chadwick Estate

50
William Cheselden (1688-1752)
Osteographia or the Anatomy of the Bones, 1733,
London
rebinding of plates from *Osteographia,* engrav-
ings by Gerard Vandergucht (1696-1776)
book; 45.5 × 31.5
Stephen Cox

51
William Clift (1775-1849)
*Catherine Welsh. Executed at the Old Bailey Monday
April 14th 1828 for the murder of her male infant,*
1828
drawing from the Sketchbook of William
Clift, *Heads of Murderers*
pencil; 23.3 × 20
The Royal College of Surgeons of England

52
John Singleton Copley (1738-1815)
Sketchbook of Anatomical Drawings, 1756
bound volume; 44.3 × 28
1864/5/14/136/143
The British Museum
London only

53 (p. 31)
Pietro da Cortona (Pietro Berrettini)
(1596-1669)
Drawings c. 1618 for *Tabulae anatomicae,* 1741,
Rome
bound volume; iron gall ink, grey wash over
black chalk on formerly blue paper
52.8 × 35.8
D1.1.29 MS Hunter 653
Special Collections Department,
Glasgow University Library

54 (p. 15)
William Cowper (1666-1709)
preparatory drawings and proof etchings,
1705-10 for *Myotomia reformata,* 1724
resting écorché in landscape: red chalk, 18 × 28
écorché falling backwards: proof etching,
12.5 × 22
study for vignette: chalk, 5.5 × 5.8
letter 'T' vignette: proof etching, 6.5 × 6.5
D.1.1.31 MS Hunter 655
Special Collections Department,
Glasgow University Library

55 (p. 62)
William Cowper
*Elongated skull viewed from beneath from Myotomia
reformata,* 1724
proof engraving; 29 × 20.6
D.1.1.31 MS Hunter 655
Special Collections Department,
Glasgow University Library

56
William Cowper
Head from Myotomia reformata, 1724
Tab. VIII proof engraving with numbers in red
handwritten listing beneath; 28 × 20.4
D.1.1.31 MS Hunter 655
Special Collections Department,
Glasgow University Library

57 (p. 62)
William Cowper after Gerard de Lairesse
(1640-1711)
*The flexor muscles of the lower arm raised through
the use of a dowel and box,* 1739
from *Anatomia corporum humanorum...,* Leiden
(originally tab. 67 in Govard Bidloo's *Anatomia
humani corporis,* 1685, Amsterdam)
engraving; 47.1 × 32
27973
Wellcome Institute for the History of Medicine
Library, London

58
Albrecht Dürer (1471-1528)
Etude d'homme nu debout, 16th century
pen and brown ink, 23.6 × 13
Inv. R.F.84
Cabinet des dessins, Musées Nationaux du
Palais du Louvre, Paris
London only

59 (p. 20)
Albrecht Dürer
Death Riding, c. 1505
charcoal; 21.1 × 26.5
1895-9-15-971 (R. 163)
The British Museum

60
Albrecht Dürer
Study for the figure of Eve, 1506
pen and brown ink with brown wash
28.4 × 9.5
1846-9-18-10 (R.167)
mounted with:
*Study for the figure of Eve holding the apple in her
right hand,* 1506
pen and brown ink with brown wash
27.8 × 9.7
1846-9-18-11 (R.168)
The British Museum
London and Warwick only

61
Albrecht Dürer
Study of a nude man seen from the front, 1526
pen and black ink and yellow wash; 45 × 24.8
Sl. 5218-186 (R. 252)
The British Museum
Leeds only

62 (p. 80)
Albrecht Dürer
Study of a nude man walking in profile to the left,
1526
pen and black ink and yellow wash; 44.8 × 24.2
Sl. 5218-185 (R. 251)
The British Museum
London and Warwick only

63
Max Ernst (1891-1976)
La femme 100 têtes, 1929, Paris
book; 25 × 20
20959
Tate Gallery Library

64 (p. 61)
Max Ernst
Une semaine de bonté ou les sept éléments capitaux,
1934
Jeanne Bucher, Paris
book; 29 × 23
7 ERN.S 1256
Tate Gallery Library
© ADAGP, Paris and DACS, London 1997

65 (p. 60)
Charles Estienne (c.1505-1564)
De dissectione partium corporis humani, 1545
Simon de Colines, Paris
book; 38.7 × 26.4
Ab.1.8
Special Collections Department,
Glasgow University Library

66
Francesco Fanelli (active 1610-1665)
Little Laocoon sculpture, 17th century
bronze; 11.1 (height)
Inv. no. M14.1952
The Syndics of the Fitzwilliam Museum,
Cambridge

67 (pp. 65, 68)
Odoardo Fialetti (1573-1638)
*Il vero modo et ordine per dissegnar tutte le parti et
membra del corpo humano,* 1608, Sudelet, Venice
volume of etchings; 14.5 × 19
1972 U.208 (1-33), 163*a.36
The British Museum

68
John Flaxman (1755-1862)
Motion and Equilibrium of the Human Body, undated
manuscript notebook, pen and ink, graphite
on paper; 2.22 × 23.17
MS 832/7
The Syndics of the Fitzwilliam Museum,
Cambridge
London only

69
Battista Franco (c. 1510-61)
Anatomical study of a man in profile, mid-17th
century
pen and brown ink; 39.1 × 13.2
Inv. no. 0103 JBS 140
The Governing Body, Christ Church, Oxford
London and Warwick only

70 (p. 70)
Philips Galle (1537-1612)
*Walking écorché, facing to the right, with detached
arm,* 16th century
engraving; 23 × 16
26115
Wellcome Institute for the History of Medicine
Library, London

71 (p. 36)
Jacques Gamelin (1738-1803)
*Nouveau recueil d'ostéologie et de myologie, dessiné
d'après nature...,* 1779
book; 53 × 38
1928-7-16-76 (1-96), 161*b.22
The British Museum

72 (p. 89)
Jacques-Fabien Gautier d'Agoty (c.1717-1785)
Muscles of the head, 1746
published successively in *Essai d'anatomie en
tableaux...,* 1745-46, Paris and in *Myologie
complette en couleur...,* 1746, Paris
coloured mezzotint; 52.8 × 36
33491
Wellcome Institute for the History of Medicine
Library, London

73
Jacques-Fabien Gautier d'Agoty
Muscles of head, eye and larynx, 1746
published successively in *Essai d'anatomie en
tableaux...,* 1745-46, Paris and in *Myologie
complette en couleur...,* 1746, Paris
coloured mezzotint; 52.9 × 36.5
33381
Wellcome Institute for the History of Medicine
Library, London

74 (p. 91)
after Jacques-Fabien Gautier d'Agoty
*An anatomical Virgin and Child: a seated woman
with open womb and foetus in her lap, hand on breast,*
18th century
oil on canvas; 200.5 × 64.5
ICV 17466R
Wellcome Institute for the History of Medicine
Library, London

75
after Jacques-Fabien Gautier d'Agoty
*Two dissected male figures, one seated, the other
standing behind, with viscera on the floor in the fore-
ground,* 18th century
oil on canvas; 203 × 65.5
ICV 17465L
Wellcome Institute for the History of Medicine
Library, London

76
Bernardino Genga (1655-1734) and
Giovanni Maria Lancisi (1654-1720)
Anatomia per uso et intelligenza del disegno, Rome,
1691
book; 49.1 × 37.5
Ay.2.18
Special Collections Department,
Glasgow University Library

77
Théodore Géricault (1791-1824)
Four Studies of the Severed Head of a Man,
c. 1818
pencil on paper; 20.9 × 27.6
Inv. no. D.2157
Musée des Beaux-Arts et d'Archéologie,
Besançon
London only

78 (p. 13)
Théodore Géricault
Studies for The Raft of the Medusa, 1818-19
pen and ink on paper; 24.2 × 34.3
Private collection

79
Jacques de Gheyn II
A Frog Lying on its Back Clasping a Bone,
1596-1602
pen and brown ink on buff paper; 15.6 × 12
D. 5077a
A Frog Lying on its Back with 'Human' Hands,
1596-1602
pen and brown ink on buff paper; 12 × 13
D. 5077b
National Gallery of Scotland, Edinburgh

80
Jacques de Gheyn II (1565-1629)
Studies of two plucked chickens hung on nails,
1596-1602
pen and brown ink over black chalk, laid down
16.7 × 15.5
Emigrés, inv. no. 22.313
Cabinet des dessins, Musées Nationaux du
Palais du Louvre, Paris
London only

81 (p. 39)
Jacques de Gheyn II
The Anatomy Lesson of Doctor Pieter Paauw,
c. 1615
title page for *Primitiae anatomicae de humani corporis
ossibus* by Pieter Paauw, Leiden
engraving; 28.5 × 22.3
The Visitors of the Ashmolean Museum, Oxford
Photo © Ashmolean Museum, Oxford

82
after Pier Leone Ghezzi (1674-1755)
*Bartholomaeus Eustachius (1520-1574) performing
a dissection*, 1714
title page to edition of Eustachius, with com-
mentary by G.M. Lancisi, Amsterdam, 1722
engraving; 10.8 × 16.2
BRN 25346
Wellcome Institute for the History of Medicine
Library, London

83 (p. 22)
Giorgio Ghisi (1520-1582) after
Antonio Lafreri (1512-1577)
The Vision of Ezekiel, 1554
engraving; 41 × 68
B.69 V 5-93
The British Museum

84
Robert Gober (b. 1954)
Untitled, 1990
beeswax, human hair and pigment
61.6 × 43.2 × 28
Courtesy of the artist

85
Benjamin Robert Haydon (1786-1846)
*Dorsal view of upper part of body lying on anatomy
table, drawn from above*, early 19th century
ink and red and grey wash; 44 × 32.5
B/37/46
Royal Academy of Arts, London

86 (p. 35)
attrib. to Nicholas Hilliard (1547-1619)
*Mystery and Communality of Barbers and Surgeons
of London*, c. 1580
Dissection scene from a set of painted plates
commissioned by John Bannister (1533-1610)
oil on paper; 29 × 38
MS Hunter 364, V.1.1, frontispiece
Special Collections Department,
Glasgow University Library

87
attrib. to Nicholas Hilliard (1547-1619)
Nerve figure from a set of painted plates com-
missioned by John Bannister, c. 1580
oil on paper; 55.5 × 40.5
MS Hunter 364, V1.1
Special Collections Department,
Glasgow University Library

88 (p. 109)
William Hogarth (1697-1764)
The Analysis of Beauty, Plate 1, 1753
etching with engraving; 38.5 × 49.8
C.c. 1-154
The British Museum

89 (p. 105)
after William Hogarth
The Reward of Cruelty from *The Four Stages
of Cruelty*, 1750-51
woodcut by John Bell; 46.5 × 38.5
Paulson 190 C.c. 2-171
The British Museum

90
Wenceslaus Hollar (1607-1677) after
Leonardo da Vinci (1452-1519)
*5 etchings based on anatomical drawings by Leonardo
da Vinci*, published 1645-1651
P. 1773: 8.2 × 9; P. 1774: 8.2 × 10;
1645 P. 1768: 9 × 6.5;
1645 P. 1772: 10.8 × 7.6; P. 1771: 13 × 7
The British Museum

91
Wenceslaus Hollar
*6 etchings for A Book of Drawinges Performed
according to the best order for use and Brevity that is
yet Extant...*, 1650
printed and sold by Peter Stent at the Whitehorse
in Guiltspur Streete without Newgate, London
P. 1750: 11.3 × 7.5; P. 1753: 15 × 8;
P. 1757: 12 × 9.4; P. 1756: 16 × 8.1;
P. 1760: 12 × 8; P. 1761: 14 × 8.2
The British Museum

92
Anon after Jean-Antoine Houdon (1741-1828)
Standing écorché figure, 1920-40
plaster model of the bronze écorché
anatomical figure; 74.5 × 31 × 42
A651631
Science Museum, London

93
Giles Hussey (1710-1788)
Album of Drawings, 1750-80
bound volume; 37 × 29
1953-11-10-5(1-350)
The British Museum
London only

94 (p. 55)
Johannes of Frankfurt after
Antonio Pollaiuolo (1431/32-1498)
The Battle of the Nudes, c. 1480
woodcut; 42 × 61
1845-8-25-587
The British Museum

95
François Jollat (1490-1550) for Charles
Estienne
*A male écorché standing, leaning against a tree, exposing
the anatomy of his thorax and his left breast*, 1545
(verso) folio C4 from *Les figures et portraicts des
parties du corps humain*
woodcut with watercolour; 27.2 × 20.2
38851
Wellcome Institute for the History of Medicine
Library, London

96 (p. 37)
Johannes de Ketham (active late 15th century)
Fasiculo di medicina, 1493, Venice
book; 31 × 20
1863-11-14-488/497, 163.a.9
The British Museum

97
Paul Kilsby (b. 1953)
After Pietro da Cortona IV, 1994
printed by 31 Studio
platinum-palladium print; 59.7 × 47
Private collection

98
Karen Knorr (b. 1954)
A Model of Vision, 1994-97
cibachrome colour print mounted on aluminium
101.5 × 101.5
Courtesy Maureen Paley/Interim Art

99 (p. 107)
Charles Landseer (1800-1879)
View of muscles of thorax of supine cadaver,
19th century
red and black chalks, heightened with white
on oatmeal paper; 32 × 52.7
8566
Wellcome Institute for the History of Medicine
Library, London

100
Heinrich Lautensack (1522-1568)
*Der Circkels und Richtscheyts auch der Perspectiva
und proportion der Menschen und Rosse*, 1564
Sigmund Feyerabend, Frankfurt-am-Main
book; 31 × 21.4
1924-4-15-23 (1-46), 159.a.5*
The British Museum

101 (p. 45)
Leonardo da Vinci (1452-1519)
*Two drawings of the skull seen from the left,
the one below squared for proportion. With notes
on the drawings*, 1489
pen and brown ink (two shades) over
black chalk; 18.8 × 13.4
RL 19057r
Royal Library, Windsor Castle, lent by Her
Majesty the Queen
Photo: Windsor Castle, Royal Collection
© HM the Queen
Leeds and London only

102 (p. 49)
Leonardo da Vinci
Studies of the reproductive system, c. 1508-09
pen and brown ink (two shades) over traces
of black chalk; 19.1 × 13.8
RL 19095v
Royal Library, Windsor Castle, lent by Her
Majesty the Queen
Photo: Windsor Castle, Royal Collection
© HM the Queen
Leeds and London only

103 (p. 46)
Leonardo da Vinci
*Three drawings of the model of a left leg in 3 positions
(profile left and right and facing) showing bones with
muscles and tendons being represented as copper wires;
entire space filled with notes*, c. 1508-09
pen and brown ink over traces of black chalk
21.5 × 11
RL 12619 (C.V.1R)
Royal Library, Windsor Castle, lent by Her
Majesty the Queen
Photo: Windsor Castle, Royal Collection
© HM the Queen
Leeds and London only

104
Leonardo da Vinci
The surface muscles of the neck and shoulder,
c. 1510-11
pen and brown ink (two shades) with wash
modelling over traces of black chalk
28.5 × 19.5
RL 19003r (C.III.2)
Royal Library, Windsor Castle, lent by Her
Majesty the Queen
Leeds and London only

105
Leonardo da Vinci
*Studies of bones of a right arm and one half raised
forearm and foetus in the womb*, c. 1511-13
pen and ink over traces of black chalk on
white paper; 28.5 × 20.6
RL 19103v
Royal Library, Windsor Castle, lent by Her
Majesty the Queen
Leeds and London only

106 (p. 47)
Leonardo da Vinci
Studies of the valves and sinuses of the heart,
c. 1512-13
pen and dark brown ink (two shades)
on blue paper; 28.3 × 20.5
RL 19082r (K&P 171 CLL 12 r)
Royal Library, Windsor Castle, lent by Her
Majesty the Queen
Photo: Windsor Castle, Royal Collection
© HM the Queen
Leeds and London only

107 (p. 74)
William Linnell (1826-1906)
Écorché Study after Smuglarius, 1840
pen and ink and highlights in body colour
over graphite on brown paper; 72 × 44
PD 32.1990
The Syndics of the Fitzwilliam Museum,
Cambridge

108 (p. 29)
Monogrammist RS
Interiorum corporis humani partum viva delineato,
1562-63
flap anatomy published by Giles Godet
handcoloured woodcut; 42.2 × 41.2
1860-4-14-264
The British Museum

109
Carlo Maratti (1625-1713)
Accademia della Pittura (The School of Design),
1682
Modello for an etching in reverse made by
Nicolas Dorigny in 1728
pen and brown ink with brown wash, height-
ened with white bodycolour, over preliminaries
in black chalk and indented with a stylus
40.2 × 31
Chatsworth 646
Lent by the Duke of Devonshire and the
Chatsworth Settlement Trustees

110 (p. 33)
Crisostomo Martínez (1638/41-1694)
Skeletal Group, c. 1685
etching with some engraving; 68 × 53
Inv. no. 1941.9.18.6
The British Museum

111
attrib. to Michelangelo Buonarotti (1475-1564)
*The muscles of the left leg, seen from the front, and
bones and muscles of right leg in right profile, and a
patella*, c. 1515-1520
red chalk; 27.3 × 20.2
26058
Wellcome Institute for the History of Medicine
Library, London

112 (p. 6)
attrib. to Michelangelo Buonarotti
*Écorché of a Male Leg: on the left, an extended
right leg and the same leg seen from the back*, c. 1520
red chalk; 28.2 × 20.7
RL 0803 (P&W 441)
Royal Library, Windsor Castle, lent by Her
Majesty the Queen
Photo: Windsor Castle, Royal Collection
© HM the Queen
Leeds and London only

113 (p. 13)
Raffaele da Montelupo (c. 1505-1566/67)
Anatomical and other Studies, 16th century
black and red chalks; 29.3 × 19.8
PII 408
The Visitors of the Ashmolean Museum,
Oxford

114
Eadweard Muybridge (1830-1904)
Studies of Human Locomotion: Man Digging, 1887
collotype; 41.6 × 18.2
Michael and Jane Wilson Collection

115
Eadweard Muybridge
*Studies of Human Locomotion: Woman Throwing
Ball*, 1887
collotype; 36.4 × 21.8
Michael and Jane Wilson Collection

116
Bartolomeo Passarotti (1529-1592)
A muscular nude carrying a wasted corpse,
16th century
pen and brown ink on white paper; 43 × 26.1
Chatsworth 33 (Jaffe 598)
Lent by the Duke of Devonshire and the
Chatsworth Settlement Trustees

117
Bartolomeo Passarotti
Le leçon d'anatomie, 16th century
38.5 × 54
Inv. 8472
Cabinet des dessins, Musées Nationaux du
Palais du Louvre, Paris
London only

118
attrib. to Bartolomeo Passarotti
Two écorchés facing right, 16th century
pen and brown ink on paper; 42.9 × 27.9
26563
Wellcome Institute for the History of Medicine
Library, London

119 (p. 94)
André-Pierre Pinson (1746-1828)
Femme assise, anatomie de viscères (Seated female figure), end 18th century
coloured wax; 40 × 25 × 30
[inv # 088-5]
Laboratoire d'Anatomie Comparée
Muséum National d'Histoire Naturelle, Paris
Photo © B. Faye

120 (p. 95)
André-Pierre Pinson
Myologie de la face et du tronc. Modèle en cire du Cabinet du Duc d'Orleans, end 18th century
coloured wax; 48 × 20 × 20
[inv # 096-6]
Laboratoire d'Anatomie Comparée
Muséum National d'Histoire Naturelle, Paris
Photo © B. Faye

121
copy after André-Pierre Pinson
La femme à la larme (Woman with a tear). Tête de femme coupée verticalement. Modèle en cire du Cabinet du Duc d'Orleans, 1784
coloured wax; 62 × 33 × 24
[inv # 093-6]
Laboratoire d'Anatomie Comparée
Muséum National d'Histoire Naturelle, Paris

122 (p. 18)
Marc Quinn (b. 1964)
Stripped Monochrome (BW), 1997
stainless steel, rubber and plaster
395 × 90 × 60
Courtesy Jay Jopling, London
© Marc Quinn 1997
Photo © Stephen White

123
Raphael (Raffaello Santi) (1483-1520)
Anatomical Study of the swooning Virgin supported by two Holy Women, 1507
pen and brown ink over chalk underdrawing
30.7 × 20.2
1895-9-15-617
The British Museum
London only

124 (p. 87)
Jan van Riemsdyck (1750-1784)
Foetus in profile, drawing for William Smellie (1697-1763), *A Sett of Anatomical Tables, with Explanations...*, 1754, London
red chalk; 56.5 × 43.5
D1.1.27 MS Hunter 654
Special Collections Department,
Glasgow University Library

125 (p. 1)
Jan van Riemsdyck
Skull on a book, c. 1755
sanguine (red chalk)
185A: 25.9 × 24.2; 186: 26.8 × 24.3;
mount: 55.7 × 35.5
185A, 186 (Hunter Boxes)
The Royal College of Surgeons of England

126
Jan van Riemsdyck
Tab. II (womb in profile)
drawing for William Hunter's (1718-1783)
Anatomy of the human gravid uterus, 1774, London
red chalk; 81.3 × 56
Az.1.4
Special Collections Department,
Glasgow University Library

127
Jan van Riemsdyck (1750-1784)
Tab. VI (foetus in womb)
drawing for William Hunter's *Anatomy of the human gravid uterus*, 1774, London
red chalk; 81.3 × 56
Az.1.4
Special Collections Department,
Glasgow University Library

128 (p. 84)
Jan van Riemsdyck
Tab. XXVI (front view of the womb)
drawing for William Hunter's *Anatomy of the human gravid uterus*, 1774, London
black and red chalk; 81.3 × 56
Az.1.4
Special Collections Department,
Glasgow University Library

129
Domenico del Barbiere after Rosso Fiorentino (1494-1541)
Two Skeletons and Two Écorchés, c. 1545
engraving; 23.6 × 33.4
Inv. no. 1851-2-8-101 (Zerner 10)
The British Museum

130 (p. 68)
P.P. Rubens (1577-1640)
Studies of Arms and a Man's Face, c. 1616-17
black and white chalk drawing; 41.1 × 31.7
Inv. Dyce 516
The Board of Trustees of the Victoria & Albert Museum
Photo: V & A Picture Library

131
after P.P. Rubens
The muscles of the forearm, 17th century
probably copy of engraving by Paulus Pontius after Rubens, c. 1610
pen and brown ink; 31 × 26
28636
Wellcome Institute for the History of Medicine Library, London

132 (p. 99)
Frederick Ruysch (1638-1731)
Thesaurus Anatomicus, 1701-16
ten parts, J. Wolters, Amsterdam
book; 38.2 × 33
EPB 45397/B
Wellcome Institute for the History of Medicine Library, London

133
Walter Hermann Ryff (d. 1562)
Omnium humani corporis partium descriptio, 1541, Strasburg
book; 27 × 19.7
X.4.5
Special Collections Department,
Glasgow University Library

134
Enea Salmeggia, called Il Talpino (c. 1558-1626)
plates from *Human Proportions*, 1607
anatomical studies, 3 male nudes
pen and brown ink; 23.9 × 17.4 cm
Inv. no. 1205 JBS 1205
The Governing Body, Christ Church, Oxford

135 (p. 75)
Jean-Galbert Salvage (1772-1813)
Anatomie du gladiateur combattant, applicable aux beaux arts..., 1812
Chez l'Auteur, Paris
book; 32.5 × 36
EPB F.576
Wellcome Institute for the History of Medicine Library, London

136 (p. 23)
Giulio Sanuto (active 1540-1580)
The Musical Contest between Apollo and Marsyas, 1662
engraving on 3 sheets of paper; 54 × 132
National Gallery of Scotland, Edinburgh

137 (p. 73)
Cindy Sherman (b. 1954)
Untitled (#261), 1992
from the series *Sex Pictures (Brehm 1996)*, 1992
colour photograph; 172.7 × 114.3
Private collection
Photo: courtesy of the artist and Metro Pictures

138 (p. 51)
Kiki Smith (b. 1954)
Uro-Genital System (male and female), 1986
diptych, bronze with green patina
male: 41 × 51; female: 51 × 28
The Saatchi Collection, London
© the artist 1997

139
after Michael Henry Spang (d. 1767)
Male écorché anatomical figure, 1750-1800
bronze figure on marble stand; 27.5 (height)
1981-1911
Science Museum, London

140 (p. 91)
Spigelius Adrianus (Adriaan van den Spieghel) (c. 1578-1625)
De formato foetu..., 1626
Opera posthuma, studio L. Cremae,
J.B. de Martinis and L. Pasquatus, Padua
34 × 22
EPB 6038
Wellcome Institute for the History of Medicine Library, London

141
John Stezaker (b. 1949)
Fall III, 1994
iris print; 118.9 × 84.1
The artist

142 (p. 25)
Stradanus (Jan van der Straet) (1523-1605)
The Arts of Painting and Sculpture, 1573
pen and light brown ink and wash heightened with white; 43.7 × 29.3
5214/2
The British Museum
London only

143
Cornelis Cort (1533-1578) after Stradanus
The Arts of Painting and Sculpture, c. 1578
engraving; 45 × 30
Ii 5-110
The British Museum

144 (p. 26)
George Stubbs (1724-1806)
Three dorsal views of the horse, progressively anatomised
preparatory drawings for *The Anatomy of the Horse*, 1766
pencil on laid paper
No. 7: 34.5 × 18.5; No. 16: 36.5 × 19.5;
No. 18: 35.8 × 18
Royal Academy of Arts, London
Photo © Royal Academy of Arts Library

145 (p. 26)
George Stubbs
Three frontal views of the horse progressively anatomised
preparatory drawings for *The Anatomy of the Horse*, 1766
pencil on laid paper
No. 9: 35.5 × 19.5; No. 17: 35.7 × 19.5;
No. 10: 35.5 × 18.5
Royal Academy of Arts, London
Photo © Royal Academy of Arts Library

146
Joseph Towne (1806-1879) from dissections by John Hilton
Sagital Head, 19th century
wax; 40.5 × 22 × 22.5
Gordon Anatomical Museum at Guy's Hospital, London

147
Joseph Towne from dissections by John Hilton
Three feet, in progressive stages of dissection, 19th century
wax; 17 × 31 × 25
Gordon Anatomical Museum at Guy's Hospital, London

148
Henry James Townsend (1810-after 1866)
A Baredon Fowl from Nature No.V, 1852
oil pastel; 22.8 × 30.5
No. 435 (888)
The Board of Trustees of the Victoria & Albert Museum

149
Henry James Townsend
Pigeon, 1852
oil pastel; 27 × 38.1
'Pigeon' Pastel No. 436 unmounted
The Board of Trustees of the Victoria & Albert Museum

150 (pp. 23, 57, 70)
Juan de Valverde de Hamusco (or Amusco) (c. 1525-c. 1587)
La anatomia del corpo humano, 1589
book; 32.9 × 23.5
Ab.1.7
Special Collections Department,
Glasgow University Library

151
Gerard Vandergucht (1696-1776)
2 drawings of a skull: preparatory drawings for William Cheselden, *Osteographia or the Anatomy of the Bones*, 1733, London
pencil on paper; 25.5 × 21; 22 × 16
H/2/1350:F
Royal Academy of Arts, London

152
Carle (André) Vanloo (1705-1764)
Figure dragging a cadaver from Figures Académiques Dessinées et Gravées par Carle Vanloo, 18th century
etching; 27.2 × 30.5
No. 254.b (29845 1-6 in Box 188)
The Board of Trustees of the Victoria & Albert Museum

153 (p. 21)
Agostino dei Musi, called Veneziano (active 1514-1536), after Rosso Fiorentino (1494-1541)
Allegory of Death and Fame, 1518
engraving; 31 × 50.8
B.424, 1857-5-2-18
The British Museum

154 (p. 113)
Andreas Vesalius (Andreas van Wesel) (1514-1564)
De humani corporis fabrica librorum epitome, 1543, Basel
book, vellum; 55.7 × 40.8
Ce.1.18
Special Collections Department,
Glasgow University Library

155 (p. 37, 41, 52)
Andreas Vesalius
De humani corporis fabrica, 1543, Basel
book; 43.5 × 30.7
Z.1.8
Special Collections Department,
Glasgow University Library

156
Andreas Vesalius
Tabulae anatomicae sex, 1538, Venice
book; 63 × 51
Az.1.10
Special Collections Department,
Glasgow University Library

157
Anon, after Vesalius
Two écorchés from De humani corporis fabrica..., 1543, Basel
brown ink with grey wash on paper; 22.2 × 32
Inv. 8619b
The Board of Trustees of the Victoria & Albert Museum

158 (p. 28)
attrib. to Stephan Calcar, after Vesalius
An anatomical dissection being carried out by Andreas Vesalius..., 1543
title page to A. Vesalius, *Epitome*, Basel
woodcut; 35.5 × 25.5
ICV no. 10668 (BRN 24285)
Wellcome Institute for the History of Medicine Library, London

159
Thomas Geminus (active 1545-1553), after
Vesalius
*Dorsal view of male écorché: Tabula 12 of
comprendiosa totius...*, 1545
engraving; 33.5 × 20.5
1982-5-15-3
The British Museum

160 (p. 24)
Enea Vico (1523-1567)
The Academy of Baccio Bandinelli, c. 1535
engraving; 30.2 × 43.7
B.49, first state, 1973 U.188
The British Museum

161 (p. 77)
Jan Wandelaar (1690-1759)
Preliminary drawing for *Tabulae sceleti et
musculorum corporis humani,* 1747
watercolour and ink; mount: 67.5 × 50
BPL 1802/03
Universiteitsbibliotheek, Rijks Universiteit
Leiden
Photo © Universiteitsbibliotheek, Rijks
Universiteit Leiden
London only

162
Jan Wandelaar
Preliminary drawing for *Tabulae sceleti et
musculorum corporis humani,* 1747
pencil, watercolour and ink; mount: 67.5 × 50
BPL 1802/10
Universiteitsbibliotheek, Rijks Universiteit
Leiden
London only

163
Jan Wandelaar
Preliminary drawing for *Tabulae sceleti et
musculorum corporis humani,* 1747
pencil, watercolour and ink; mount: 67.5 × 50
BPL 1802/15
Universiteitsbibliotheek, Rijks Universiteit
Leiden
London only

164
Charles Grignion (1716-1810) after
Jan Wandelaar (1690-1759)
Muscle-man seen from the front, 1749
engraved plate to B.S. Albinus *Tabulae sceleti et
musculorum...,* London, 1749
Tab. IV of muscle series
engraving; 92 × 73.7
ICV 8529
Wellcome Institute for the History of Medicine
Library, London

165 (p. 79)
Charles Grignion after Jan Wandelaar
Muscle-man seen from the back, 1749
engraved plate to B.S. Albinus *Tabulae sceleti et
musculorum...,* London, 1749
Tab. VI of muscle series
engraving; 92 × 73.7
ICV 8585
Wellcome Institute for the History of Medicine
Library, London

166 (p. 79)
Simon François Ravenet the elder (1706-1774)
after Jan Wandelaar
Male skeleton seen from the side, 1747
engraved plate to B.S. Albinus *Tabulae sceleti et
musculorum...,* London, 1749
Tab. III of skeletal series
engraving; 92 × 73.7
ICV 8582
Wellcome Institute for the History of Medicine
Library, London

167
Louis Gérard Scotin (1680-1755) after
Jan Wandelaar
Muscle-man seen from the front, 1749
engraved plate to B.S. Albinus *Tabulae sceleti et
musculorum...,* London, 1749
Tab. I of muscle series
engraving; 92 × 73.7
ICV 8578
Wellcome Institute for the History of Medicine
Library, London

168
James Ward (1769-1859)
Dorsal view of legs and joints, 18th/19th century
pen and grey black ink on paper; 41.2 × 32.3
PD 64/1993
The Syndics of the Fitzwilliam Museum,
Cambridge

169
John Webb after Inigo Jones (1573-1652)
*Plans and elevation for the Barber Surgeon's
Anatomy Theatre, London,* 1636
pen, incised lines; 45.7 × 35.5
The Provost and Fellows of Worcester
College Oxford

170
Joel-Peter Witkin (b. 1939)
Poet: From a Collection of Relics and Ornaments,
1986
toned gelatin silver print; 72 × 71
Galerie Baudoin Lebon, Paris

171 (p. 97)
Joel-Peter Witkin
Cupid and Centaur in the Museum of Love, 1992
hand-painted gelatin silver print with encaustic
81 × 67
Galerie Baudoin Lebon, Paris
© Joel-Peter Witkin
Courtesy Galerie Baudoin Lebon, Paris
Courtesy PaceWildensteinMacGill, New York

172
after Jan Corneliszoon van der Woudt
(c. 1570-1615)
*The Leiden Dissection Theatre (Theatrum
anatomicum),* 17th century
engraving; 20.5 × 15
The Visitors of the Ashmolean Museum,
Oxford

Lenders

UK

Her Majesty the Queen, Royal Library, Windsor Castle
The Visitors of the Ashmolean Museum, Oxford
Jonathan Bayer
Birmingham Museums and Art Gallery
The British Museum
Helen Chadwick Estate
The Governing Body, Christ Church, Oxford
Stephen Cox
The Duke of Devonshire and the Chatsworth Settlement Trustees
National Gallery of Scotland, Edinburgh
Edinburgh University Library
Department of Anatomy, University of Edinburgh
The Syndics of the Fitzwilliam Museum, Cambridge
Special Collections Department, Glasgow University Library
Gordon Anatomical Museum at Guy's Hospital, London
Jay Jopling, London
The Nasser D. Khalili Collection of Islamic Art
Maureen Paley/Interim Art
Royal Academy of Arts, London
The Royal College of Surgeons of England
The Saatchi Collection, London
Wellcome Collection, Science Museum, London
John Stezaker
Tate Gallery Library
The Board of Trustees of the Victoria & Albert Museum, London
Wellcome Institute for the History of Medicine Library, London
Michael and Jane Wilson Collection
The Provost and Fellows of Worcester College Oxford
Private Collections

France

Musée des Beaux-Arts et d'Archéologie, Besançon
Musée de l'Ecorché d'Anatomie du Neubourg (Eure - Normandie - France)
Laboratoire d'Anatomie Comparée, Muséum National d'Histoire Naturelle, Paris
Baudoin Lebon, Paris
Cabinet des Dessins, Musées Nationaux du Palais du Louvre, Paris

The Netherlands

Universiteitsbibliotheek, Rijks Universiteit Leiden

USA

Max Aguilera-Hellweg
Beth B
Robert Gober